American Beauty

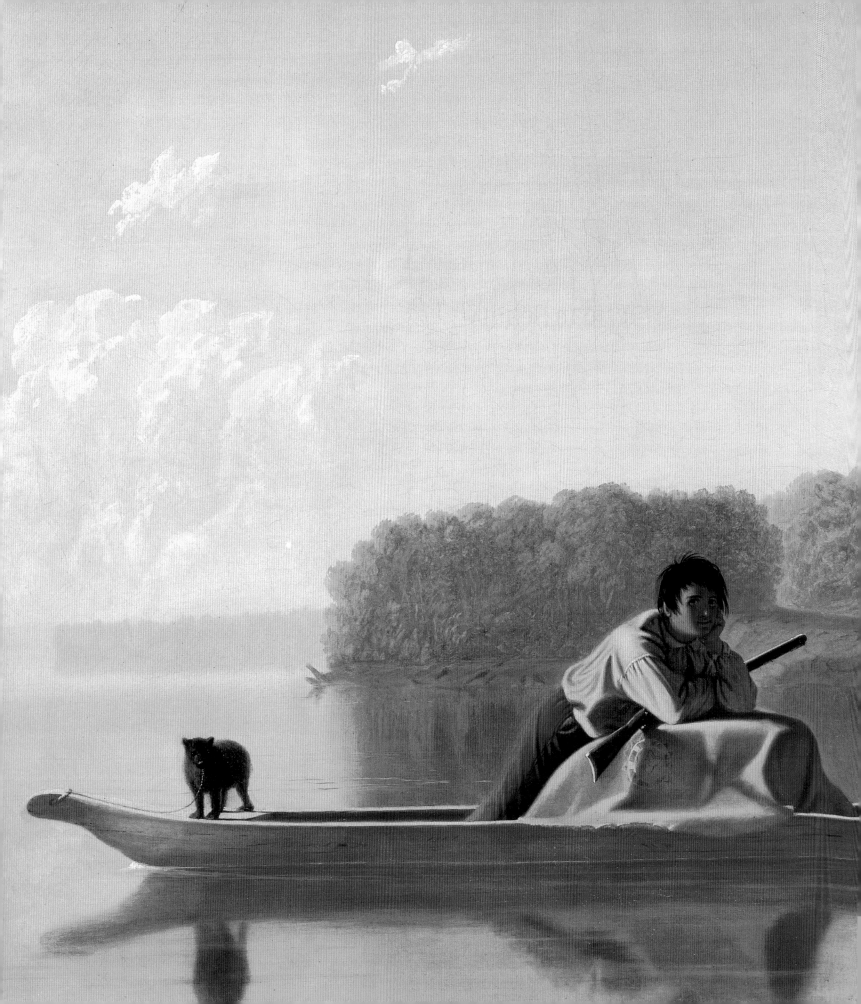

American Beauty:

Paintings from the Detroit Institute of Arts

1770-1920

Graham W. J. Beal

SCALA

Scala Publishers Ltd, 2002

First published in 2002 by Scala Publishers Ltd
Gloucester Mansions
140a Shaftesbury Avenue
London WC2H 8HD

ISBN 185759 285 9

Edited by Judith Ruskin and Elaine Garvey
Designed by Anikst Design
Printed and bound by Editoriale Lloyd, Trieste, Italy

Front cover illustration:
Detail from George Bellows' *A Day in June*, 1913

Back cover illustration:
Winslow Homer, *The Dinner Horn*, 1873

Frontispiece:
Detail from George Caleb Bingham's *The Trappers'
Return*, 1851

Acknowledgments

This book was published on the occasion of a touring
exhibition of highlights from the Detroit Institute of Arts'
acclaimed collection of American art. I have written a
straightforward, largely chronological and stylistic essay
that endeavors to tell the larger story of American art as
well as elucidating the particular qualities of individual
works of art. Neither the exhibition nor this publication
would have been possible without the dedicated work by
a number of individuals. At the Detroit Institute of Arts,
Tara Robinson, curator of exhibitions, and James Tottis,
acting curator, along with colleagues in the Department
of American Art, handled the myriad details involved in
a traveling exhibition. The book resulted from the efforts
of Susan Higman, director of publications, and Judith
Ruskin, who ably edited the manuscript. The superb
photographs were taken by members of the Department
of Visual Resources, with Dirk Bakker as director. We
are also indebted to Scala Publishers, London, for
producing this handsome publication on an extremely
tight schedule. Finally, I wish to thank the many authors
of the first two volumes of our permanent collection
catalogues, *American Paintings in the Detroit Institute of
Arts*, vol. 1, *Works by Artists Born before 1816* and vol. 2,
Works by Artists Born between 1816 and 1847, upon whose
scholarship I drew heavily for much of this book.

Graham W. J. Beal
Director, The Detroit Institute of Arts

Contents

American Beauty

 The Faces of a New Nation 7

 An Abundance of Riches: Still Life 25

 Of the People, by the People, for the People 33

 From Sea to Shining Sea: Landscape as the National School 47

 Odd Men In and Out: Painting the Imagination 67

 Interlude: Sculpture 74

 From Contretemps to Entente Cordiale 79

 Interlude: Thomas Eakins 90

 Impressionism and Realism 93

 Beautiful Ladies and the Aesthetic Movement 103

 Interlude: Sculpture 107

 The Eight 113

Notes 124

Further Reading 128

Index of Artists 128

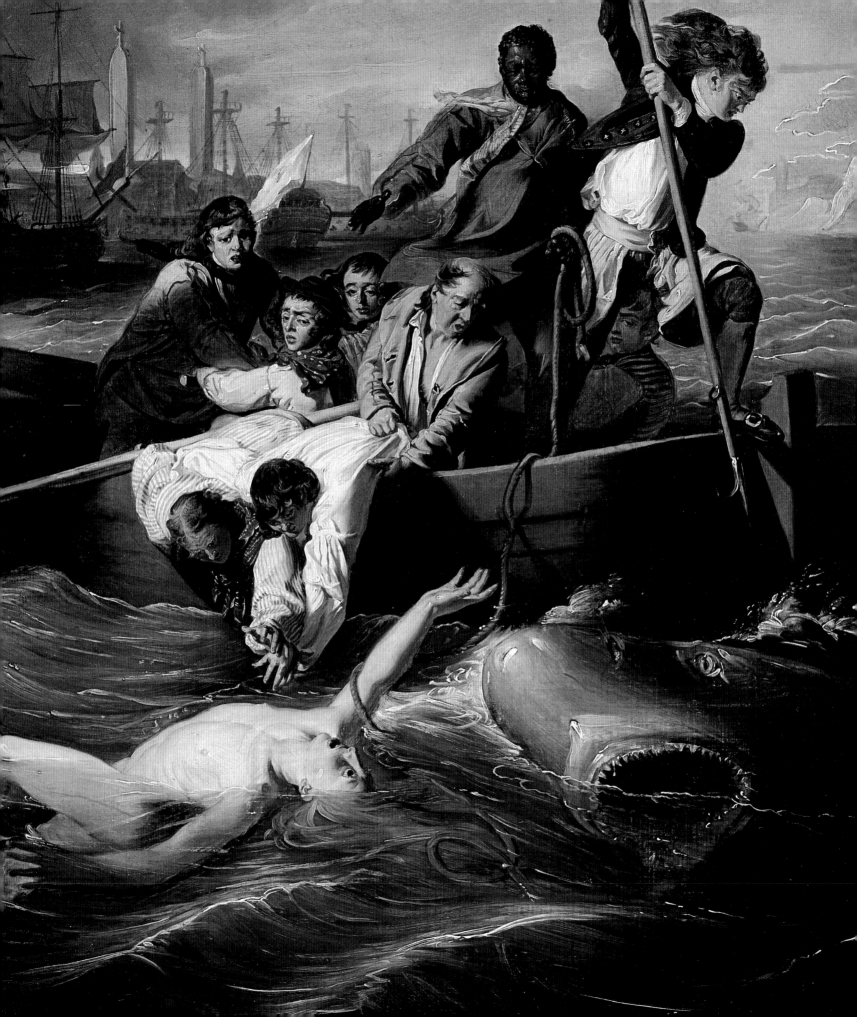

The Faces of a New Nation

John Singleton Copley, detail of *Watson and the Shark,* 1782 (fig.4)

The earliest American painters were itinerant craftsmen who, according to advertisements of the time, were as capable of decorating signs, coaches, and furniture, or even giving music and dancing lessons, as they were of turning out a good likeness. Portraits of successful merchants or professional men and their families seem to have been the exclusive subject matter of these artists; perhaps not surprising in a circumscribed society concerned mainly with industry and virtue. Here art was very much "an optional extra," as is made clear by an anonymous early Bostonian:

> The Plow-man that raiseth Grain is more serviceable to Mankind than the painter who draws only to please the eye. The hungry man would count fine Pictures but a mean entertainment. The Carpenter who builds a good House to defend us from the Wind and Weather, is more serviceable than the curious Carver, who employs his Art to please his fancy. This condemns not Painting, or Carving, but only shows, that what's more substantially serviceable to Mankind, is much preferable to what is less necessary.[1]

Seventeenth- and eighteenth-century portraiture in colonial America reflected the influence of artistic traditions of the mother countries, England and the Netherlands. The former country's own efforts in this sphere were themselves dominated by such foreigners as the Dutch-born Peter Lely and the German-born Godfrey Kneller. Engravings in general, and mezzotints in particular, were the main source of inspiration, transmitting ideas both for the composition of the paintings as well as for the dress of the sitters.

The first professionally trained artist to work in the Colonies was John Smibert. Born in Edinburgh and trained as a house painter (the situation for an aspiring artist in Scotland and England was, perhaps, not so different from that of one in America), Smibert ambitiously took himself first to London and then to Italy. After three years there he returned to London where he established a modestly successful portrait studio. In 1728, he was chosen by the Irish cleric George Berkeley as professor of art and architecture at the college the latter intended to found in Bermuda. The educational experiment failed when promised government financial support did not materialize, and Berkeley returned to Britain to become a bishop and famed philosopher. Smibert opted for New England where, with his solid and relatively sophisticated abilities, he quickly established himself as the leading artist of his day.

Smibert's death in 1751 left the field open to other New England artists, notably Joseph Badger, Joseph Blackburn, Robert Feke, and John Greenwood. Badger, in some ways artistically the most conservative of this group, is said to have augmented his income by painting houses, signs, and heraldic devices. He lived and worked near the paint store that Smibert ran to augment his income—Badger may well have acquired his materials there—but he seems to have absorbed little of the older artist's panache in his own paintings. Badger's increasingly "provincial" style may reflect prevailing taste as much as innate tendencies on the artist's part, but, even so, Badger's work tends to be less innovative than that of his immediate contemporaries. *James Bowdoin* (**fig. 1**), painted around 1746–47, is one of two nearly identical portraits (the other hangs, appropriately, at Bowdoin College, Brunswick, Maine); Detroit's painting is generally thought to be the primary version because of its greater subtlety. Bowdoin, a shipping magnate said to be New England's wealthiest citizen, had earlier commissioned a portrait from Smibert in 1735 and was probably only deflected from doing so again by the fact that the artist, suffering from failing eyesight, had been forced to give up portraiture and revert to painting "in a landskip [landscape] way." Badger mustered all his abilities to carry out this important commission and rarely matched this effort in succeeding years: depth, modeling, and detail are all at a level that generally eluded him. But the composition is unimaginative, the sitter's pose deriving ultimately from a widely circulated portrait of Sir Isaac Newton and the view of the ship upon the ocean familiar from any number of portraits of sea-going men. The pen and inkstand indicate that

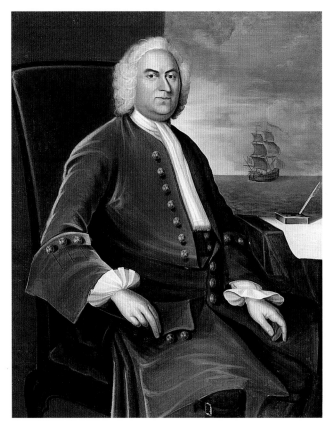

1

the subject is a merchant rather than an admiral. Bowdoin's attire is similarly conservative; the plain, dark, matching frock- and waistcoats reflect older tastes than the bright, contrasting, and embroidered garb found in the portraits of Badger's rivals. If artistic temperament and sitter's tastes were well matched with Badger and Bowdoin, it did not help the artist, whose middling talents condemned him to a long, losing struggle for success. But when he died insolvent, in 1765, it was in no small measure due to the sudden emergence of a prodigious, home-grown talent—John Singleton Copley.

Copley's career, spanning the Atlantic and embracing the Old World and the New, symbolizes the relationship at the time when the two went to war to decide who would govern the latter. Copley grew up in the closest thing to an artistic milieu that New England had to offer. His stepfather sold painter's supplies and engravings, and the Copley household was not far from Smibert's studio, maintained as something of a museum after the artist's death. Developing his own style almost independently, Copley quickly dominated the local scene and was soon garnering commissions from as far away as Quebec. By 1769 he was wealthy enough to marry into the Boston elite and buy an estate on fashionable Beacon Hill. By the same token, his unparalleled talent caused him to want more than artistic primacy in New England. In 1771 he traveled to New York where, in seven months, he produced thirty-five portraits. But Copley was painfully aware that the real standards for success as an artist were set in Europe and desperately wanted to know how his work would compare with the best that Britain had to offer. He sent a portrait to the 1766 exhibition of the Society of Artists in London, where it attracted favorable attention. Sir Joshua Reynolds, England's premier artist, sent constructive criticism; Copley's exact contemporary and fellow American painter Benjamin West, in London since 1763, urged Copley to at least study in Europe for a short while. Copley, a successful, established, family man, hesitated, but events decided for him. Although he personally counted as friends such leading colonial patriots as John Hancock (his next-door neighbor) and Paul Revere, Copley's rise into the upper echelons of Boston society had placed him among those loyal to Britain. Mounting unrest was bad for business, and in 1774, the year after the Boston Tea Party, Copley sailed to England. In 1775 he traveled to Venice, Florence, Rome, and Naples. The American War of Independence broke out while he was in Italy, and in 1776 he returned to London, to be joined there by his family. He bought a large house in Leicester Square where, alongside his continued success as a portraitist, Copley established himself as a groundbreaking history painter. He never returned to the land of his birth.[2]

1
Joseph Badger
James Bowdoin
Ca. 1746–47
Oil on canvas
Founders Society
Purchase,
Gibbs-Williams Fund
58.354

2
John Singleton Copley
Hannah Loring
1763
Oil on canvas
Gift of Mrs. Edsel
B. Ford in memory
of Robert H. Tannahill
70.900

3
John Singleton Copley
John Montresor
Ca. 1771
Oil on canvas
Founders Society
Purchase, Gibbs-
Williams Fund
41.37

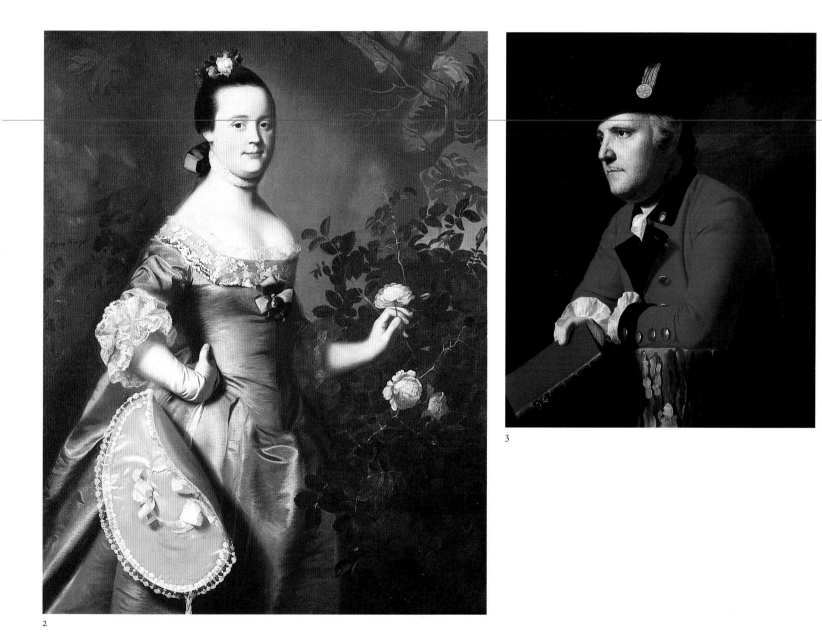

2

3

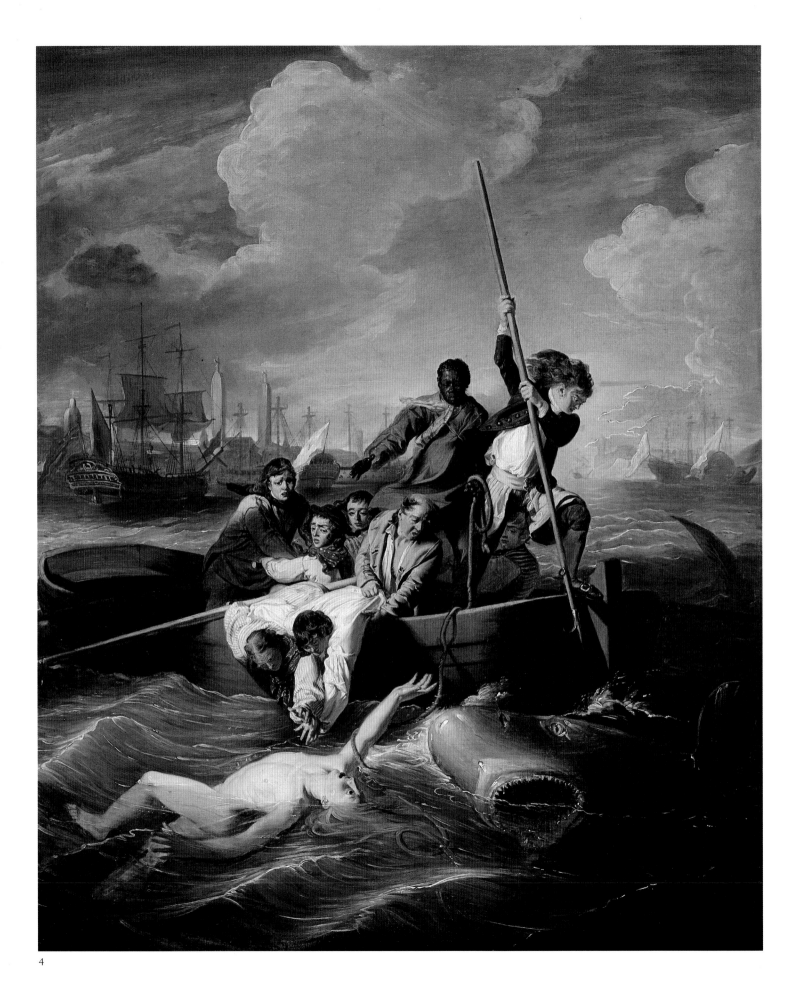

4
John Singleton Copley
Watson and the Shark
1782
Oil on canvas
Founders Society
Purchase, Dexter M.
Ferry, Jr., Fund
46.310

Copley was producing commissioned portraits by the time he was fifteen, and his early work reflects the influence of such older Boston painters as Smibert and Badger. Flat figures rendered in soft colors are set against even flatter backgrounds. Ten years later, when Copley painted the portrait of *Hannah Loring* (**fig. 2**), he had forged a distinct style that gave his patrons everything they desired: meticulous detail combined with restraint, vivacity tempered with reserve. Loring is shown engaged with the background, not just placed before it, as she fingers a pinkish red rose. The soft hue of the rose as well as that of the blue bows at her breast and neck subtly complement the silver gray of the gown, and the lushly painted bonnet that dangles from her other hand adds a delightfully nonchalant note.

It is likely that the startlingly realistic portrait of *John Montresor* (**fig. 3**) was one of the thirty-five commissions Copley executed in New York. Montresor, described as an "engineer extraordinary," was an officer in the British army who saw service in Quebec, Detroit (he drew a *Plan of Detroit and Its Environs*, probably in 1763), and at several battles in the War of Independence, retiring from active duty in 1778. He seems to have been a friend of the artist. This friendship, combined with an engineer's predilection for facts, may account for the startling realism of the portrait. Bright light rakes the sitter's face, showing up pockmarks and a five o'clock shadow. Copley shows Montresor leaning against the stump of a tree—an allusion to the kind of work engineering entailed—and holding a book with "FIELD ENGINR" stamped on its spine, thereby neatly combining the physical and mental aspects of the subject's profession.

In *Watson and the Shark* (**fig. 4**), Copley deliberately set out to further a new form of "history" painting which, while using the vocabulary of the Old Masters, took for inspiration events of the recent past. Benjamin West had led the way in 1770 with his *Death of General Wolfe*, which recorded the dramatic and crucial triumph in a war that wrested control of vast stretches of North America from Britain's perennial

enemy, France. By contrast, *Watson and the Shark* depicts a minor event, thirty or so years past, and ostensibly of little import to anyone but the victim. Brook Watson, a fourteen-year-old midshipman, was waiting with other crew members in Havana harbor to take his captain ashore and decided to take an ill-advised swim. He was attacked by a shark that severed his right leg at the knee before his comrades could rescue him. After a three-month recovery period he was, in the words of an early recorder of the event, obliged "to quit the profession of his choice, and [turn] his mind to the acquiring of instruction, adapted to mercantile pursuits."[3] Watson was born in Plymouth, England, in 1735 and, being orphaned, sent to relatives in Boston, who had ships that traded in the West Indies. Following his accident, Watson returned to Boston before moving to Canada and becoming an independent merchant. In 1759 he returned to England where he became a leading figure in London's mercantile world, eventually rising to the exalted position of Lord Mayor (1796–97).

Watson's later prestige gave currency to the distant event, while its essential contemporaneity and horrific nature permitted the artist to demonstrate his distinct talent for realism. Copley shows Watson in the water, with shredded leg, as the shark circles around for another bite. Immediately above, two colleagues reach out to pull Watson to safety, while another in the bow prepares to strike at the shark with a long gaff hook. Everything is in movement as the climax of the event approaches. The last of three versions of the painting (now in the National Gallery of Art, Washington, D.C.) was exhibited at the Royal Academy in 1778 as *A Boy Attacked by a Shark*. The Detroit version, thought to be a preparatory study, is unusual in its vertical format, which allows the artist to introduce a turbulent sky with lowering clouds and flaming sunset that seems to mirror the turmoil of the events below.

From the very beginning, *Watson and the Shark* has inspired much comment and interpretation—not all of it favorable. While many contemporaries praised its inherent artistic qualities and lauded its "awful" subject matter, later

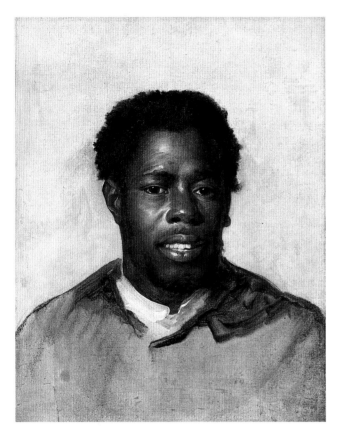

5

5
John Singleton Copley
Head of a Negro
Ca. 1777–78
Oil on canvas
Founders Society
Purchase, Gibbs-Williams
Fund
52.118

6
John Singleton Copley
Mrs. Clark Gayton
1779
Oil on canvas
Gift of Mr. D. J. Healy
27.556

commentators have fretted about the politics of Watson himself. A strident Tory, Watson was described by the patriot Ethan Allen as "a man of malicious and cruel dispostion…who…behaved towards the prisoners with that spirit of bitterness, which is the peculiar characteristic of the tories when they have the friends of America in their power."[4] Others, incensed by Watson's fierce proslavery stance, attacked the painting's very premise, claiming that "in spite of [Watson's] later elevation as Lord mayor of London and Baronet of the United Kingdom, there are those whose sympathy is with the shark."[5] Still others have suggested that the painting is an allegory of the dismemberment of the British

Empire, with Watson's severed leg representing the lost colonies.[6] In light of such indignation and speculation, it is perhaps ironic that the work—probably commissioned by Watson himself—may have been intended as a lesson in personal salvation; the story of a young and foolish man who, when given a second chance, went on to make something of himself. Watson's own will, at least, indicates that he eventually—if not always—held that view. He bequeathed the original to Christ's Hospital "hoping that said worthy Governors…will allow it to be hung up in the Hall of their Hospital as holding out a most usefull Lesson to Youth."[7]

Standing behind the gaff hook-wielding sailor is a man of African descent, who has just thrown a lifeline to Watson. His presence in the painting, and its possible symbolism, has been the cause of much speculation, and his prominence is unprecedented in the history of British or American painting. Reviewers' comments of the time reveal rather more about their own prejudices than critical acumen. One suggested that "instead of being terrified, he ought to be busy. He has thrown a rope over to the boy. It is held, unsailorlike, between the second and third finger of his left hand and he makes no use of it."[8] As Copley's preliminary drawing for the figures in the boat shows a nearly identical figure with Caucasian features, it is unlikely that the artist intended a racial slight. Rather, he has given this figure a central role and there can be little doubt that the inclusion was complimentary and, to some degree, personal. *Head of a Negro* (**fig. 5**) was described in an 1864 sale following the death of Copley's son as "Head of a Favourite Negro. Very fine. Introduced in the picture of 'The Boy saved from the Shark.'" (It sold for eleven guineas.) The obvious warmth that radiates from the picture encourages the notion that there was a bond between artist and sitter. Combining the careful observation of his earlier American work with a new fluidity of brushstroke, *Head of a Negro* indicates that Copley was already learning from the work of established English portraitists, notably George Romney who, newly arrived in London from Italy, was in his

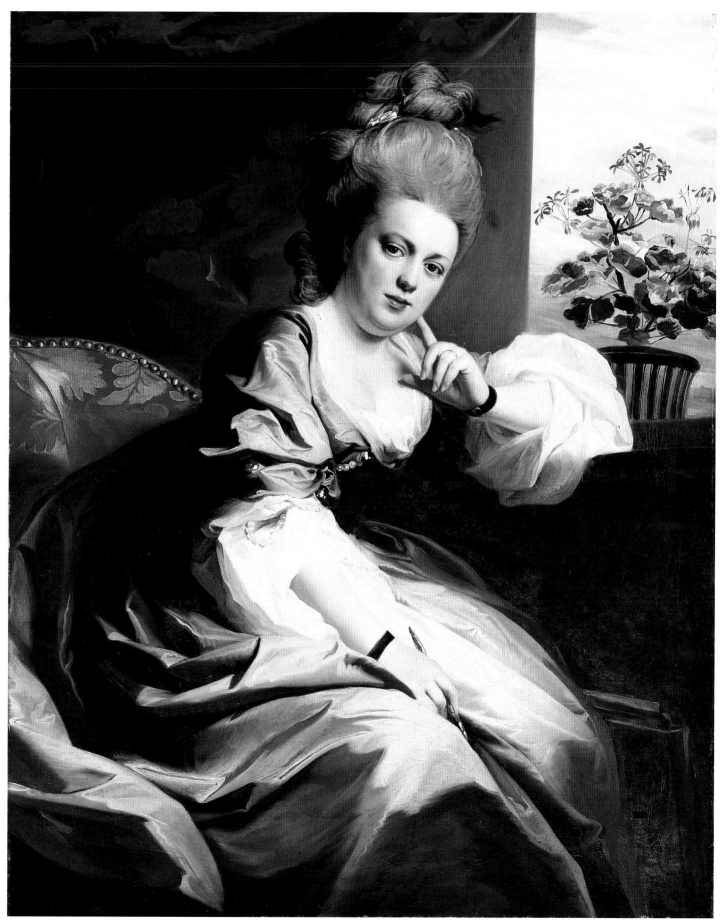

7

prime in the late 1770s. These lessons are fully deployed in Copley's 1779 portrait of *Mrs. Clark Gayton* (**fig. 6**), where the artist lays the paint down freely across the whole composition, adding to the animation of the woman's pose.

While Copley was the leading painter in Boston, Benjamin West was the dominant American artist in London. Born in Pennsylvania in 1738, West had a short career as a portraitist, before going, at age twenty-two, to Italy for three years. Arriving in London, he spent the rest of his career in the British capital, where he died in 1820. Eventually knighted, painter to King George III, recipient of an annual royal retainer of one thousand pounds, a founder of the Royal Academy, and its second president, West and his English success give rise to the question of just how "American" he was. Whatever his personal politics, West never ceased to identify himself as an American and always showed the utmost concern for the personal and creative welfare of artists from his native land.

The list of figures who went through his studio, receiving formal and informal instruction, reads like a veritable *Who's Who* of American painting. Aside from Copley, and mentioning only those represented in the Detroit Institute of Arts' collection, they included Charles Willson Peale, Gilbert Stuart, Thomas Sully, and Washington Allston.

West's sojourn in Italy occurred at the height of revived interest in classical antiquity. Excavations at Pompeii and elsewhere were constantly unearthing treasures, and books were being published by antiquarians and architects placing these discoveries in a new light. In this environment, the young man from eastern Pennsylvania was transformed into an artist of high-minded ambition and, on his arrival in England, quickly found himself at the center of the debates concerning the character and purpose of art. But he never ceased to relate his learning to the land of his youth. On first seeing the *Apollo Belvedere*, West is said to have delighted his

7
BenjaminWest
Death on the Pale Horse
1796
Oil on canvas
Founders Society
Purchase, Robert H.
Tannahill Foundation
Fund
79.33

8
Washington Allston
The Flight of Florimell
1819
Oil on canvas
City of Detroit Purchase
44.165

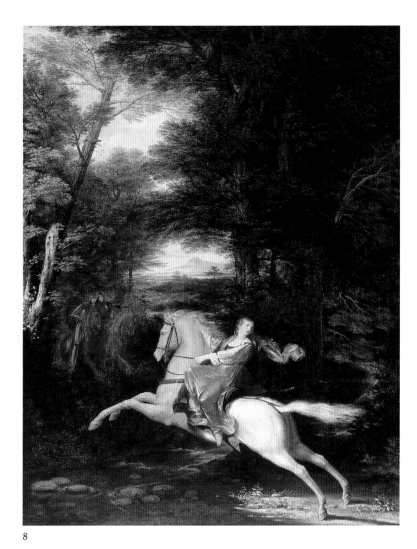

8

Italian hosts by spontaneously exclaiming, "My God, how like a Mohawk warrior."[9]

In his early years in London, West continued to paint portraits for a living, but the success of his 1771 painting, *The Death of General Wolfe,* established his reputation as a history painter. After 1780 his output was overwhelmingly biblical and historical. His style, although retaining aspects of classicism, evolved into a personal sort of "neobaroque" epitomized by the 1796 painting *Death on the Pale Horse* (**fig. 7**). Conceived of as part of an extensive series, Detroit's painting is the first of several on this subject. The event depicted is described in the Bible: "And I looked, and behold a pale horse: and his name was Death, and Hell followed with him" (Revelation 6:7). West places Death and his horse in the center of the composition, accompanied to the right by the other three Horsemen of the Apocalypse. An obvious source for the painting is Dürer's print *The Four Horsemen of the*

Apocalypse, but Rubens's influence is apparent in the rendition of the horses and the tumbling composition. When first exhibited in London, *Death on the Pale Horse* won widespread approval. In 1802 the painting was exhibited to acclaim in Paris and seen by Napoleon Bonaparte who, according to one biographer, asked to buy it.[10] Britain was at war with France almost continuously from 1793 to 1815, and it is tempting to see West's picture as a reflection of the disastrous state of affairs precipitated by the French Revolution and the attempted liquidation of the upper orders. While West had initially conceived the composition in 1783, he may have revived it in light of these events. Certainly, his patron William Beckwith noted the connection when he prophesied that Britain's inept government would bring disaster: "Over deserted smoking plains, pale Napoleon will be galloping. It will be West's Apocalypse, his Triumph of Death, painted in the same terrible colours, a mingling of mire and blood."[11]

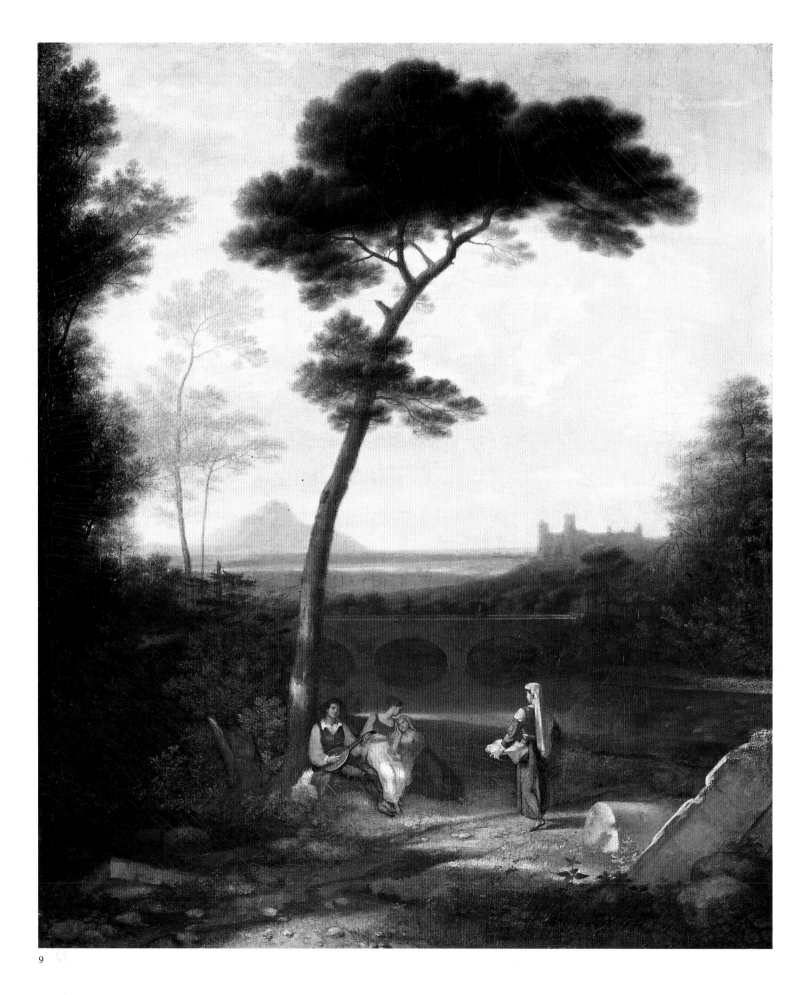

9

9
Washington Allston
Italian Landscape
1828–30
Oil on canvas
Founders Society
Purchase, Dexter M.
Ferry, Jr., Fund
43.31

Arriving in London in 1801, Washington Allston immediately enrolled in the Royal Academy schools, where he studied for two years. Accompanied by fellow American artist John Vanderlyn, Allston toured Europe until 1808. In Rome, he formed enduring friendships with the writers Washington Irving and Samuel Taylor Coleridge. His use of Venetian glazing techniques earned him the sobriquet "the American Titian." Returning to America in 1808, he settled in Boston where he painted portraits before returning to Europe in 1811 and, over the next seven years, pursued his goal to become a great history painter. He met with considerable success, but by the time he returned to Boston in 1818, the taste for huge historical compositions imbued with high moral purpose was giving way to a preference for lyrical and intimate subjects, qualities very much apparent in his *The Flight of Florimell* (**fig. 8**) of 1819 and *Italian Landscape* (**fig. 9**) of 1828–30. Edmund Spenser's sixteenth-century epic poem *Faerie Queene* was a source of inspiration for many writers and artists at the beginning of the nineteenth century, but it seems to have had a special appeal to Allston. In this depiction of a scene from the poem, Allston hews close to Spenser's description of Florimell as this symbol of chastity bursts into a clearing in front of two knights: a "goodly lady" whose "face did seem as clear as crystal stone" and "garments wrought of beaten gold" upon a "milk-white steed" with "tinsel trappings" that "fled so fast." The landscape behind is delicately painted and reflects the influence of the sixteenth-century Venetian artists that Allston so admired.

Allston produced dozens of paintings called *Italian Landscape* between 1805 and 1830, all works of the imagination and all combining standard props of the romantic landscape: peasants, classical and medieval ruins, a hazy atmosphere, and soft sunlight that bathes a distant mountain (seen in reverse profile in *The Flight of Florimell*). Among Allston's *Italian Landscape* paintings, Detroit's is the only known vertical piece; a format that increases its debt to the work of Claude Lorrain, the virtual inventor of this kind of generalized vertical landscape. Claude was widely collected in eighteenth-century Britain, and Allston must have been very familiar with his work.

Gilbert Stuart was another American artist who benefited from Benjamin West's generosity. The son of Scottish immigrants, Stuart grew up in Rhode Island. He received his early training from the miniaturist Cosmo Alexander and when, around 1772, Alexander returned to his native Scotland, Stuart went with him. Stuart returned to Rhode Island in 1773, apparently after Alexander's death, and established a practice producing portraits in a smooth miniaturist style. In 1775, after a stint in Boston, Stuart went to London where, for two years, he struggled unsuccessfully to establish himself as a painter, at one stage earning his keep as an organ-grinder. West responded to Stuart's appeal for help by taking him in as a studio assistant. His talent blossomed under West's tutelage, and in 1782 Stuart caught society's attention with several pieces exhibited at the Royal Academy. He had absorbed all the lessons of contemporary British portraiture and painted with verve. Unlike many of his contemporaries, Stuart had no desire to be a painter of "great" subjects. He reveled in making portraits, particularly the early stages of capturing a likeness, and his remarkable ability to do so brought him a steady stream of commissions. His financial stability was undermined by extravagant living, and Stuart fled London for Dublin. There the process repeated itself, but, this time, he was unable to avoid debtors' prison. Shrewdly calculating that the new establishment in the United States would require an endless stream of likenesses for official purposes, Stuart returned to America working in New York and Philadelphia before following the government to Washington, D.C. His quest to paint George Washington, the new nation's first president, was successful, and Stuart thereafter never lacked for commissions. In 1805 he moved to Boston where he remained for the rest of his life, generally acknowledged as the leading American artist of his day.

10
Gilbert Stuart
General Amasa Davis
Ca. 1820
Oil on panel
Gift of Mrs. J. Bell Moran
45.17

11
Thomas Sully
Dr. Edward Hudson
1810
Oil on canvas
City of Detroit Purchase
26.89

12
Thomas Sully
Mrs. Edward Hudson
1814
Oil on canvas
City of Detroit Purchase
26.90

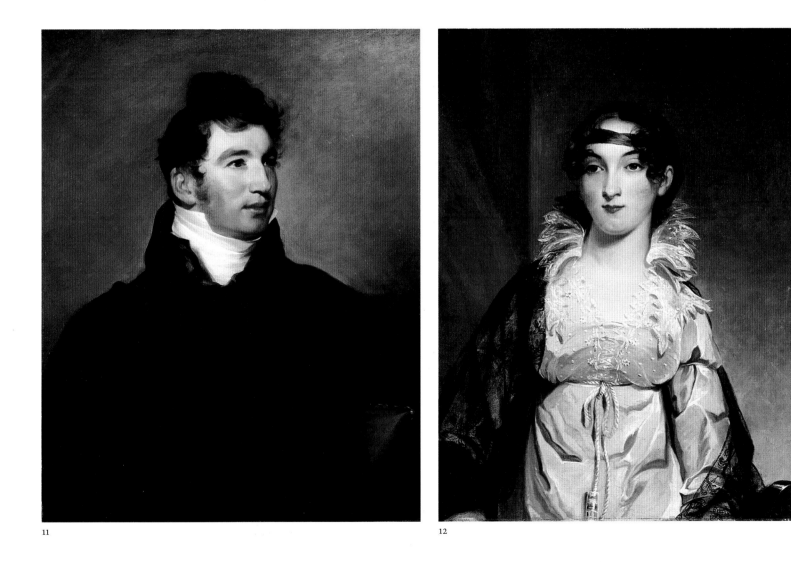

11

12

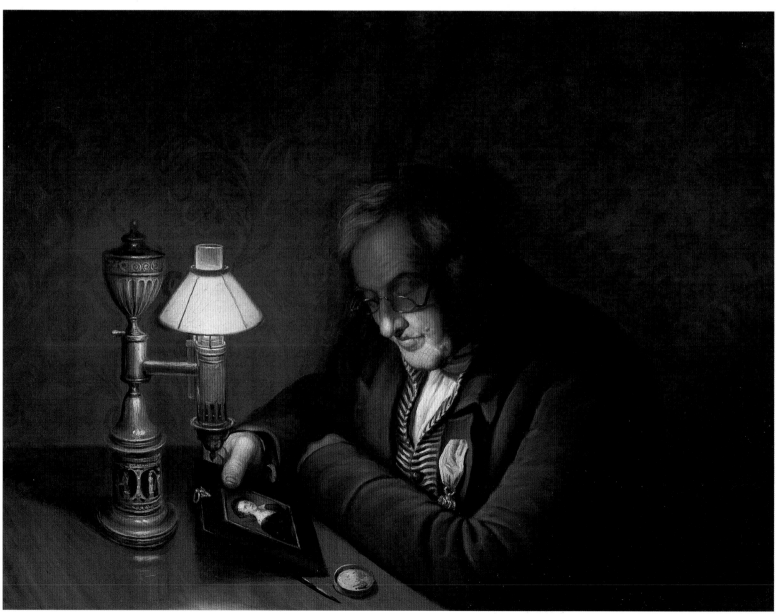

13

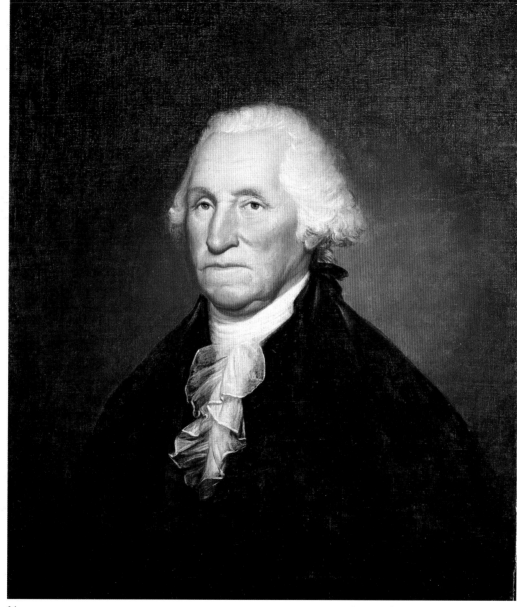

13
Charles Willson Peale
*James Peale (The
Lamplight Portrait)*
1822
Oil on canvas
Founders Society Pur-
chase with funds from
Dexter M. Ferry, Jr.
50.58

14
Rembrandt Peale
George Washington
1795–96
Oil on canvas
Gift of Mrs. James
Couzens
61.163

14

The portrait of *General Amasa Davis* (**fig. 10**), painted around 1820, displays many of the qualities that made Stuart a most sought-after portraitist. The subject—a successful merchant and officer in the War of Independence—looks out at the viewer, his face animated by a quizzical expression. Flickers of paint enliven the surface, adding to the sense of spontaneity. Stuart worked quickly, frequently finishing a head in three sessions, talking all the while to the sitter. As he aged, his brushstroke became more tremulous, as can be seen in the Davis portrait. Someone watching him work in the 1820s commented: "It is interesting to see how Stuart, with shaking hand, would poise the brush above his work, and

then, stabbing it suddenly, get the touch he desired."[12]

Thomas Sully received art instruction from a series of painters, including Gilbert Stuart, before settling in Philadelphia in 1807. A year or so later, probably at Stuart's urging, he went to England with a letter of introduction to Benjamin West. By this time the grand old man was less inclined to take pupils and, absorbed with his mission to create great subject paintings, had little sympathy with Sully's determination to be a portrait painter. West referred the young American to Sir Thomas Lawrence, Britain's premier portraitist of the day. Sully returned to Philadelphia in 1810 and, painting in a modified Lawrencesque style, he quickly

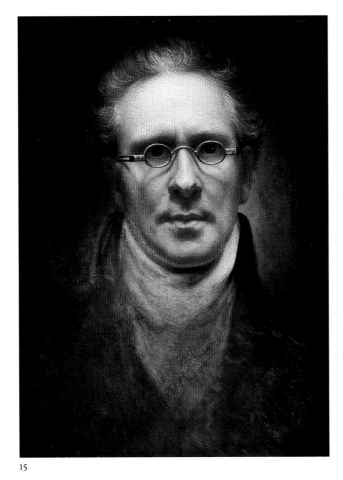

15

15
Rembrandt Peale
Self-Portrait
1828
Oil on canvas
Founders Society Pur-
chase, Dexter M. Ferry,
Jr., Fund
45.469

established himself as that city's leading portrait artist. The pendant portraits of Dr. and Mrs. Edward Hudson (**figs. 11** and **12**) show a freshness and ease of handling that is typical of his best work. John Neal, an art critic in Philadelphia at the time, described Sully's work as "beautiful and tranquil: or romantick, and spirited. His characteristics are elegance, and taste. He is not remarkable for strength or fidelity…but…surpassing gracefulness, and a careless unstudied richness."[13]

Sully had succeeded Charles Willson Peale as Philadelphia's premier portraitist. Peale first studied painting under John Hesselius (an artist of Swedish descent) at the same time he ran a business as a saddlemaker, upholsterer, metal- and glassworker, and clock repairer. In 1765 he traveled to Boston to seek guidance from Copley and, the following year, with the support of a group of Maryland businessmen, went to London to be among the first American artists to benefit from Benjamin West's tutelage. In 1778, following three years of service with the Continental Army, Peale set himself up as an artist and inventor in Philadelphia. The museum he established at the same time gradually took more and more of his attention, and, by 1800, he was referring most portrait business to his sons. Peale, who married three times, had a sizable brood, many of whom he named after artists: Raphaelle, Angelica Kauffman, Rembrandt, Titian (twice), Rubens, Sophonisba Anguisciola, and Rosalba Carriera. His work was continually experimental and, even in his old age, he set tests for himself. His 1822 portrait of his younger brother, *James Peale (The Lamplight Portrait)* (**fig. 13**), was the result of one such set of experiments. In that year he wrote his son Rembrandt, "I make a bold attempt by *the light behind me* [his emphasis], and all my features lit up by a reflected light, beautifully given me by the mirror…That you may understand me place yourself between a looking glass and the window."[14] Only weeks later he started *The Lamplight Portrait*, which shows James, a well-known miniaturist, examining a miniature, painted by his daughter, by the light of a lamp. In

a subsequent letter to Rembrandt, Charles Willson Peale wrote, "The brightest light is on the end of his nose downward, the forehead has only the light through the shade of the lamp, a miniature pallet [*sic*] and pencil on the table show that he is a painter."[15] Peale shows his brother literally "warts and all," but the work is an affectionate tribute to the talents of a large, artistically accomplished family, many of whose members had received their training from Charles.

For much of his life, Rembrandt Peale labored under the burden of being the son of Charles Willson Peale. Perhaps more so than any of his brothers, Rembrandt sought to sustain his father's aims while trying to establish his own. Many of his early portrait commissions were given to him by his father. He even attempted, with his brother Raphaelle, to open versions of his father's Philadelphia museum in Baltimore. This effort, as well as an attempt, this time with his brother Rubens, to make money in 1802 by exhibiting one of his father's mastodon skeletons in London, failed. While in London, however, he benefited from contact with his father's old teacher, Benjamin West. To further improve Rembrandt's skills, his father underwrote two trips to Paris between 1808 and 1810. Rembrandt Peale's ambition to displace Gilbert Stuart—whom he simultaneously admired and envied—as Philadelphia's most sought-after portrait painter also failed, although he produced a sequence of superb paintings in this line.

One of the highlights of Rembrandt Peale's career occurred in 1795–96 when he painted a portrait of George Washington (**fig. 14**). Peale idolized the first president and took deep personal satisfaction in the fact that they shared the same birthday. The painting was commissioned by Henry William de Saussure on his retirement from the directorship of the U.S. Mint in Philadelphia, and Rembrandt secured the job in part through his father's personal connections with Washington. Although, after the first sitting, Rembrandt Peale was joined by several brothers and his father at the easel ("in danger of being peeled all round" was Gilbert Stuart's famous quip),[16]

he found the experience utterly grueling, leaving him almost unable to mix his colors. The Detroit picture is one of two surviving copies of the ten the artist made in Charleston immediately after completing the commission. Despite his worship of Washington, Rembrandt's depiction of the first president differs markedly from that of Gilbert Stuart. Where Stuart shows a vigorous man with a finely sculpted head, Peale depicts a weary-looking old man with small eyes, big nose, and downturned mouth. Even the shoulders slide dispiritingly away. Peale had relished the opportunity to see his hero every morning *en déshabillé* before being prepared for the sittings; some of this experience seems to have crept into the painting.

In the course of his life, Rembrandt Peale painted several self-portraits in the same format: essentially full-face and wearing his characteristic steel-framed spectacles. The Detroit *Self-Portrait* (**fig. 15**), of 1828, was painted for his wife, Eleanor, on the eve of a trip to Europe. It combines intimacy and immediacy in a way that recalls the self-portraits of his seventeenth-century namesake, Rembrandt van Rijn. Peale's face is in tight focus, the stock and lapels loosely brushed. Art historian William T. Oedel sums up the work succinctly:

He revered the truth—that is one theme of the present painting—and the spectacles…which he wore constantly, were a fact of his appearance and were essential to his livelihood. As Peale planned his European tour, anxious about his impaired health as well as the dangerous voyage, he took stock of himself and found both a restless dreamer and a temperate, blunt pragmatist who was devoted to his art. Most of his later self-portraits are slick public affairs: this one is a confession.[17]

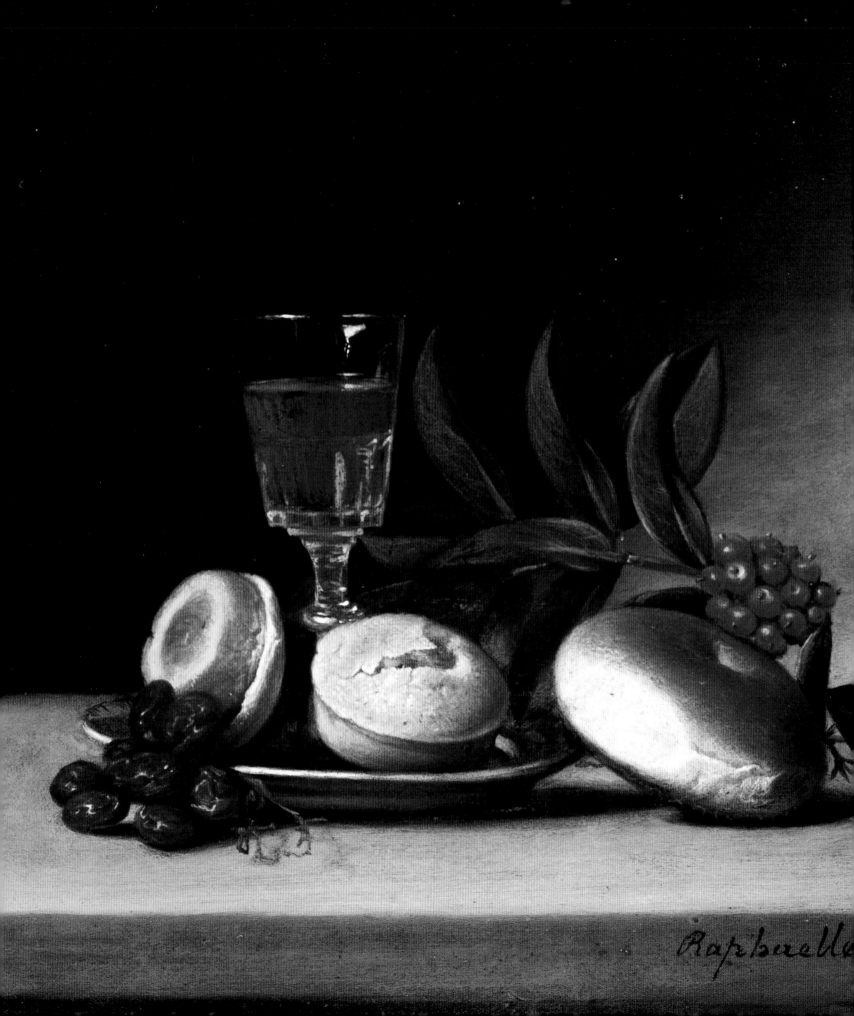

An Abundance of Riches: Still Life

The art of painting portraits cannot be attained without a vast deal of practice, the artist must love the art, or he will not succeed to perfection. It is not like the painting of still life; the painting of objects that have no motion, which any person of tolerable genius, with some application may acquire.[18]

So Charles Willson Peale wrote to his wayward son Raphaelle. Just as two generations before, Benjamin West had eschewed portraiture as unworthy of the highest aims of painting, so Peale *le père* endeavored to steer what he thought was his most talented offspring back to a higher calling. Raphaelle had, in fact, started his career as a portraitist, picking up, with his brother Rembrandt, some of their father's business when, in 1794, the elder Peale decided to dedicate himself to his museum. But Raphaelle Peale's larger oil portraits were not well received and, although he also worked as a miniaturist in the first years of his career, heavy drinking and increasing attacks of gout interfered with the discipline required for this medium. Perhaps propelled by some Oedipal impulse as well as an innate sense of his own talent, by 1812 Raphaelle was concentrating on still life and receiving considerable public acclaim. *Still Life with Wine Glass* (**fig. 16**) is typical of his best work; restrained yet somehow slightly opulent, it deploys a few objects in such a way as to evoke a sense of well-being. A glass of Madeira, or sherry, sits behind a couple of cakes on a plate. To the left is a bunch of raisins, to the right, sprays of fresh red berries and a small loaf of bread. A wide array of visual textures (as well as implied taste sensations) is encompassed in a very small pyramidal group, and it is easy to see why the moneyed classes delighted in this reminder of the rewards that accompanied a successful and well-regulated life. It is also not difficult to read into such a work moral and autobiographical subtexts—most notably the artist's own failure to restrain his own appetites.

The late-blooming artistic career of Rubens Peale extended the family's legacy well beyond the midpoint of the nineteenth century. Possessing extremely poor eyesight, Rubens was trained by his father in natural history and museum management, successfully overseeing Charles Willson Peale's museum for more than thirty years. After failed museological experiments with his brother Rembrandt (Baltimore, 1822–25) and on his own (New York, 1825–37—he sold out to P. T. Barnum), Rubens retired to a farm in Schuylkill Haven, Pennsylvania, where he immersed himself in animal husbandry and the study of nature. The return to Schuylkill Haven of his daughter Mary Jane, who had been trained as a portraitist by his brother Rembrandt, inspired Rubens to take up painting in 1855. He spent the last ten years of his life producing—largely for his own pleasure—more than 130 landscapes, still lifes, and depictions of fauna, as well as copies after works by other family members. In taking up painting at the age of seventy-one, Rubens "became the only member of his family who pursued four of his father's occupations: agriculturalist, naturalist, museum manager, and artist."[19]

Although much of Rubens Peale's work is, not surprisingly, derivative of that of his brothers and father, his depictions of animals and birds stem entirely from his own observations. *Two Ruffed Grouse* (**fig. 17**) was one of several works portraying a favorite American game bird. The inscription on the back, "Painted by Rubens Peale in his eightieth year, April, 1864," not only conveys the old man's justifiable sense of pride, it also closely echoes one his father had attached to his 1822 self-portrait: "Painted in the 81st year of his age without spectacles." For all Rubens Peale's personal observation, technical care, and pride, however, *Two Ruffed Grouse* has a slightly naïve quality. The authentic background habitat of evergreen, laurel, and white oak is schematic. The postures and positioning of the birds—female, on the left pecking downward; male, on the right watchfully erect—are heavily reminiscent of ornithological illustrations. Still, it is likely that this composition and similar ones held special significance for the artist. In 1860 his wife had sheltered a family of grouse, something Peale committed to canvas seven times between 1861 and 1864. At the time that he painted the

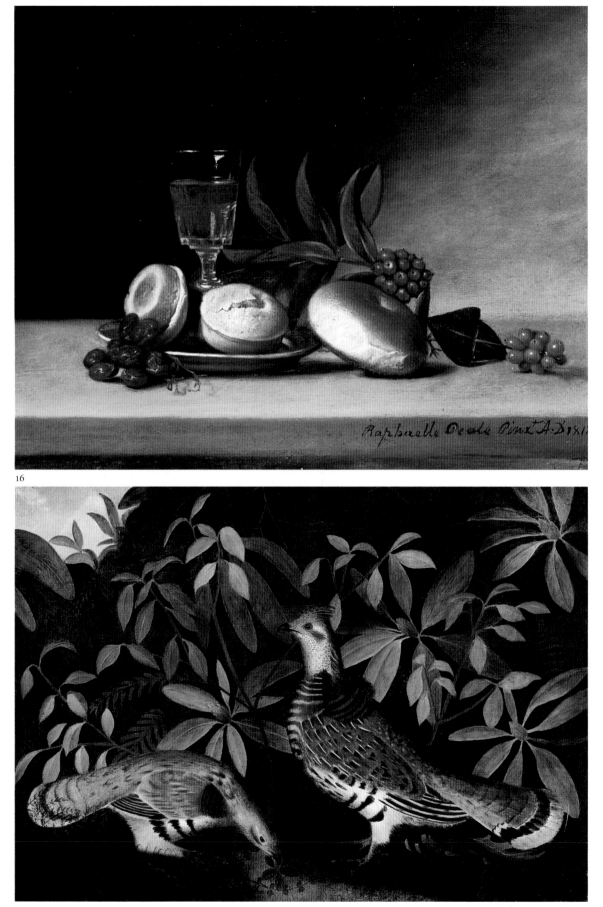

16

17

16
Raphaelle Peale
Still Life with Wine Glass
1818
Oil on panel
Founders Society
Purchase, Laura H.
Murphy Fund
39.7

17
Rubens Peale
Two Ruffed Grouse
1864
Oil on canvas
Gift of Dexter M. Ferry, Jr.
43.41

18
John F. Francis
Still Life with Yellow Apples
1858
Oil on canvas
Founders Society
Purchase, Gibbs-
Williams Fund
75.58

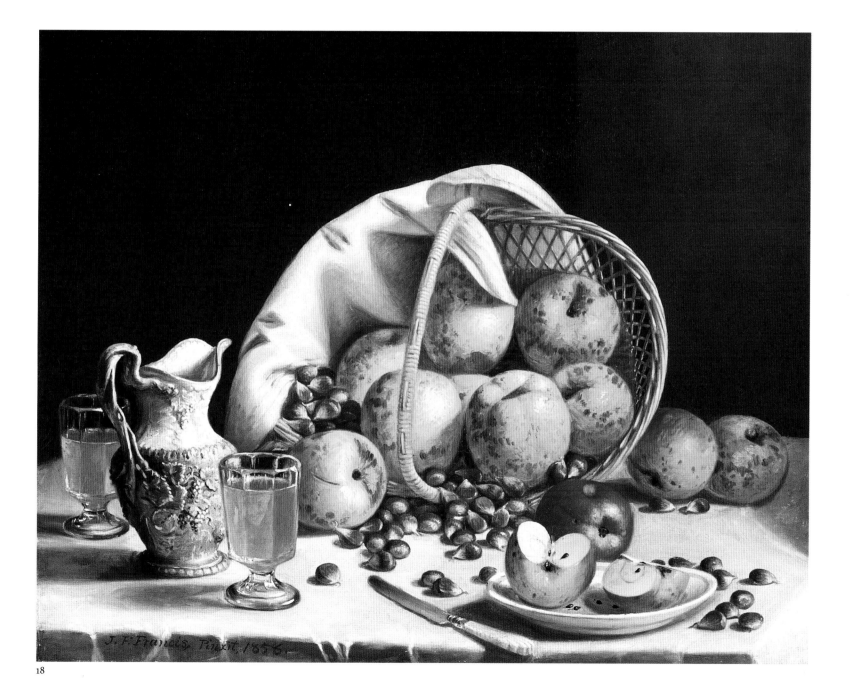

18

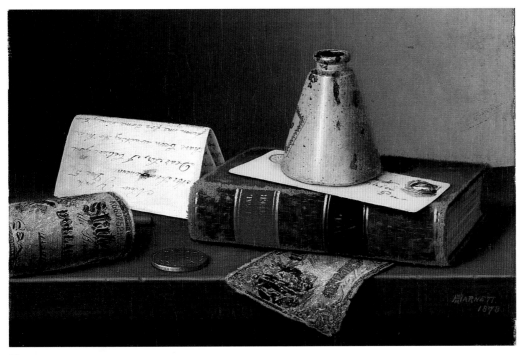

19

grouse pictures, his wife's health was rapidly declining, and it is possible to interpret them "in terms of his wish to commemorate bygone happiness in his own family as well as to cling to its present day remnants in those final hours."[20] After his wife's death, Peale returned to Philadelphia where he died the following year, leaving his youngest brother, Titian Ramsay II, to carry the family torch of naturalist and painter for another twenty years.

The career of John F. Francis is indicative of how portraiture lost its position at the center of American painting. Until about 1850, Francis worked as an itinerant portrait painter in his native state of Pennsylvania as well as in Ohio and Tennessee. Listed as a resident of Philadelphia in 1840, he regularly exhibited at the Academy of Fine Arts between then and 1858, and his portrait style for the first ten years clearly reflects the influence of the city's reigning practitioner,

Thomas Sully. In 1850 he suddenly shifted his emphasis to still life, apparently abandoning portraiture altogether by 1852. Perhaps, as has been suggested, he grew tired of the constant travel required of his portrait business; perhaps he was pulled toward still life by favorable comments from patrons on the floral accessories he included in many of his portraits of women.[21] Perhaps, like Raphaelle Peale, he discovered a new market that fitted more closely with his own painterly predilections. Finally, perhaps he saw the likely effect on his traditional livelihood of the new, infinitely cheaper portrait medium of photography, invented in 1839 and gaining ground rapidly across the western world. Whatever the reasons for his shift to still life, Francis's preferred subject matter was fruits and nuts, interspersed with the objects necessary for their consumption, and glasses and pitchers of drink. He worked in a number of formats—large and small, many

19
William Michael Harnett
American Exchange
1878
Oil on canvas
Gift of Robert H. Tannahill
46.304

20
John Frederick Peto
After Night's Study
Ca. 1890/1900
Oil on canvas
Gift of Robert H. Tannahill
48.386

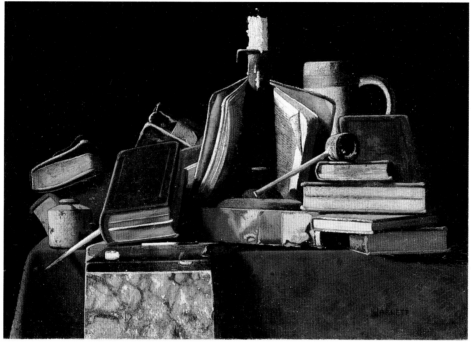

20

objects to few—but his 1858 *Still Life with Yellow Apples* (**fig. 18**) is among his most accomplished canvases. A trompe l'oeil knife, hanging over the front edge of the table, leads the viewer into a carefully balanced composition based on primary colors threaded through with browns. Placid and solid, such a work exudes a sense of plentiful satisfaction far removed from the edgy individuality of Raphaelle Peale's work.

William Harnett established a school of trompe l'oeil still-life painting that was designed to thrill the American audience through its eye-fooling realism, which often contained clues to enable more attentive viewers to pick out a story. Born in Ireland, Harnett was raised in Philadelphia and began his career as an engraver, notably of silver. He attended the Pennsylvania Academy of the Fine Arts before moving to New York, where he continued his art studies and engraving while beginning to make a living as a painter of still life.

He returned to Philadelphia in 1876 and re-enrolled in the Academy, now much changed through the presence of Thomas Eakins. Eakins's direct influence on Harnett appears to have been limited to improving the latter's technique and ability to handle light. *American Exchange* (**fig. 19**), painted in 1878, is an essay in the kind of unaffected realism that informs so much American painting, continuing the home market's demand for accuracy when tested against the real thing. Whatever the opinions of Charles Willson Peale and those others who, wishing to transform the European tradition of the Grand Manner in painting into something suitable for the new Republic, the public demanded something closer to home. Gilbert Stuart was close to the mark when he quipped that, while in England, his efforts were merely "compared with those of Van Dyck, Titian, and other great painters—but here they compare them with the works of the Almighty."[22]

Several decades later, the English traveler Frances Trollope would recall that in America, when the subject of portraiture came up, "the finish of drapery was considered as the highest excellence, and next to this, the resemblance in a portrait: I do not remember ever to have heard the words *drawing* or *composition* used in any conversation on the subject."[23] *American Exchange* exploits such bias and shows a small group of fairly humble objects of differing textures on a shelf: a stoneware inkstand sits atop a beaten leather-bound book; between them is a crisp envelope. From under the book a tattered and crinkled banknote protrudes and hangs off the shelf. A gleaming coin, another dollar bill (this time loosely rolled), and a folded letter complete the picture. A hint of a story can be deduced from the envelope's address— "[Philadel]phia, Penn"—and the words visible on the letter: "New York, Dec 5. Mr. Stephenson. Dear Sir, I believe you have been waiting to hear from me for some time, but." But, of course, the real subject of the painting is the skill of the painter and his ability to thrill, if not actually fool, the eye. Shortly after painting *American Exchange*, Harnett went to England, where he found little recognition. He moved on to Germany and there developed the larger, dazzling, trompe l'oeil format for which he is best known.

While at the Pennsylvania Academy, Harnett met the slightly younger John Peto. Unlike Harnett, who found success, Peto languished in obscurity, and his work was, for many years, often confused with that of the older artist— sometimes, it would seem, deliberately. Harnett moved on from the humble objects of *American Exchange* to more exotic accoutrements, but Peto stuck with the mundane and the battered. His brushwork, too, is less polished and, although his arrangements of objects can be read symbolically, he seems, above all, interested in the play of light. Peto's *After Night's Study* (**fig. 20**)—to which someone later added Harnett's signature inscription—presents a pile of well-used books, a burnt-out candle, a pipe, and a tankard. A raking, morning light strikes the edges of many of the objects, giving

structure and even monumentality to this pile of ordinary things. But, as in so much of Peto's work, a sense of melancholy prevails. Compared to Harnett's jaunty *American Exchange*, *After Night's Study* is an American memento mori.

John Haberle was entirely self-taught. *Grandma's Hearthstone* (**fig. 21**) was commissioned by a Massachusetts newspaper tycoon who had torn the fireplace and mantle out of his home, then transported them to the artist's studio to serve as Haberle's model. Virtually life size, the painting depicts a fire burning in a hearth, with every kind of object hanging, propped, and perched around it. The message conveyed is the evergreen one of "the good old days." Lacking the brilliance of Harnett's work or the mood of Peto's, *Grandma's Hearth* has a naïve quality, a characteristic enhanced by the mixed trompe l'oeil message of the painted mantelshelf protruding over the painted frame surrounding the "walk-in" realism of the main image. No painted fire, of course, can fool the eye, although "It Fooled the Cat," according to a newspaper account of the time, which went on to relate how the animal curled itself up in front of the painted fire, purred, and went to sleep.[24]

21
John Haberle
Grandma's Hearthstone
1890
Oil on canvas
Gift of C. W. Churchill in
memory of his father
50.31

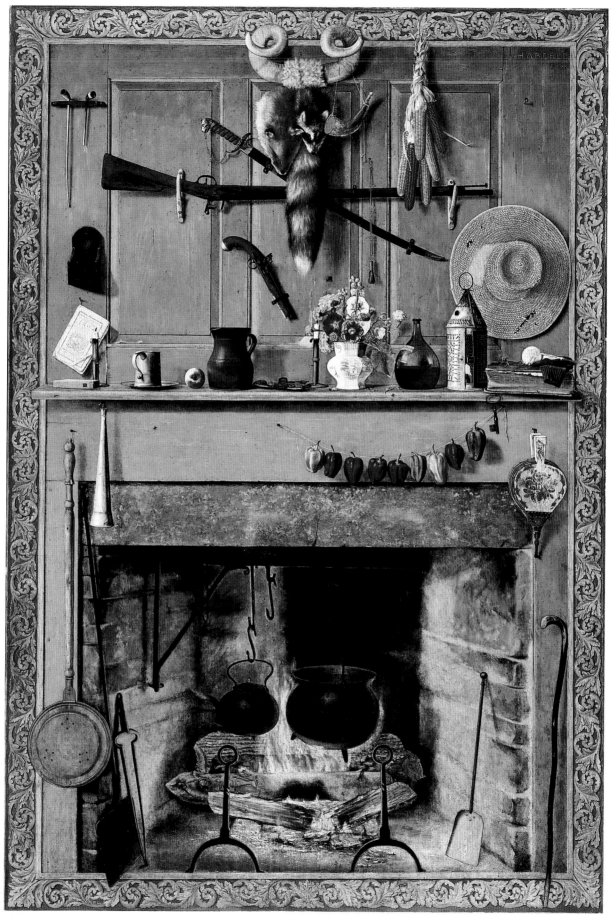

21

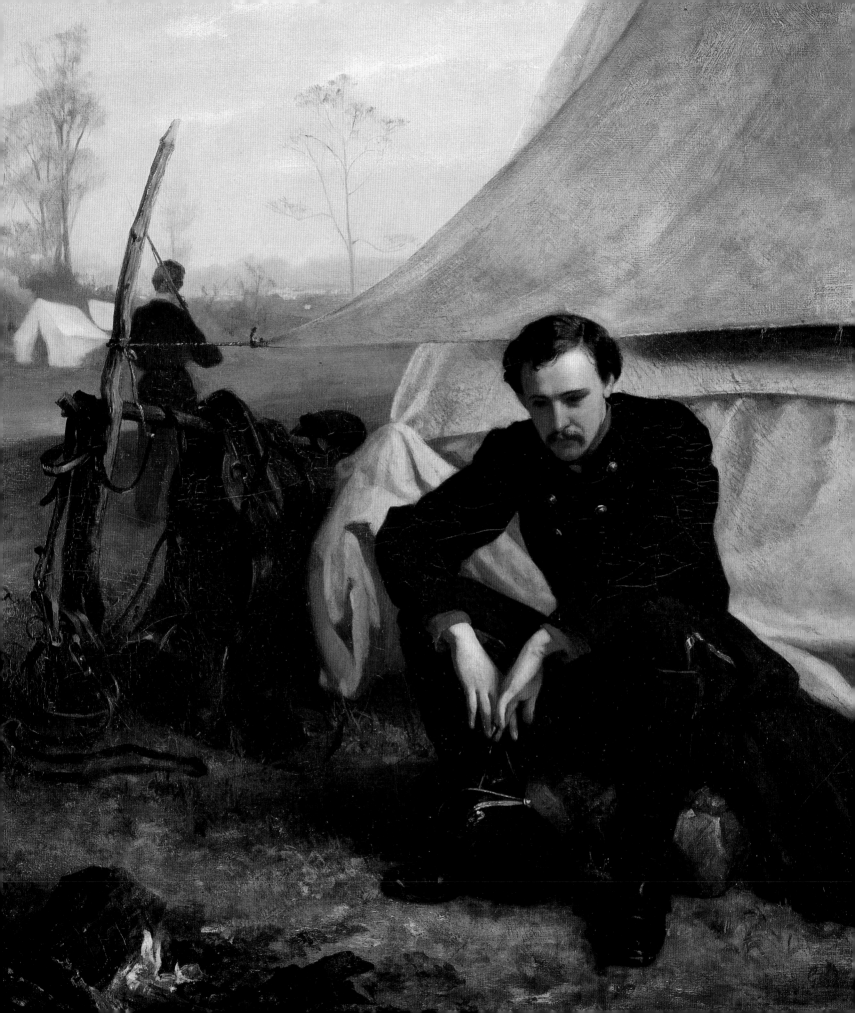

Of the People, by the People, for the People

George Cochran Lambdin, detail of *At the Front*, 1866 (fig. 28)

If the faces of the new ruling classes seemed to dominate the art of the first fifty years of the new Republic, by the 1820s they were being challenged by those of the people. Not, however, in formal portraiture, but in genre scenes, pictures of ordinary folk at work and at play. First and foremost in exploring this area were William Sidney Mount and George Caleb Bingham. For inspiration they both stayed close to home, New York's Long Island for Mount, Missouri for Bingham. For financial security they both relied on easy, popular understanding of their subject matter, disseminated through widespread and lucrative lithographic prints. Their art was, as has often been remarked, the art of Jacksonian democracy —the advent of the Common Man—but imbued with echoes of Jefferson's fading ideal of an agrarian democracy.

Mount, a painstaking and self-disciplined artist, combined a determination to be original with a fear of being overwhelmed by outside influences. He studied only briefly at the new Academy of Design in New York and with the portrait painter Henry Inman, before establishing a studio on his beloved Long Island to pursue his goal of producing "comic pictures" along the lines of those by the Dutch seventeenth-century masters. Although he shuttled happily between his studio and New York City, he turned down three offers of funds for trips to Europe on the grounds of inconvenient scheduling and the fear of losing what he called "his nationality."[25]

But Mount was more than a self-isolated painter of "comic" scenes. His pictures were always firmly composed, often incorporating strong architectonic components, and painted with meticulous care. He was, furthermore, among the earliest to address directly the issue of race, often presenting the black man (or woman) as an essential part of American life, yet perpetually marginalized within it. *The Banjo Player* (**fig. 22**), satisfying though it may seem to "Postimpressionist" eyes, is unfinished. The single musician, apparently playing for his own benefit, was originally to have had an audience, and recent technical examination has revealed the ghostly presence of two high-stepping figures,

outlined in faded white paint. Lacking the figures, the smile on the musician's face inevitably suggests a sense of contentment (he appears not to be looking at the would-be figures, anyway), of someone secure in a world of his own. The impression of privacy is further accentuated by the "box within a box" compositional device created by the open barn door and the frame of the picture itself.

In contrast to Mount's rural world with its concentration on farming, George Caleb Bingham delighted in depicting what was unequivocally the frontier. In the 1840s, Missouri— and St. Louis in particular—was the springboard for a series of expeditions to secure the vast Oregon Territory (today the states of Washington, Oregon, and Idaho) for the United States. These exploratory journeys attracted any number of adventurers who mingled with earlier inhabitants, many of whom were of French descent. This was the rough-and-ready world to which Bingham was inexorably drawn. Born on a plantation in Virginia, Bingham, at age eight, had moved with his parents to Franklin, Missouri. By 1833 he was working as an itinerant portraitist there, journeying to New York, Philadelphia, and Washington, D.C., to hone his skills as a painter. Although he was successful in securing portrait commissions, he was able to establish his reputation as a painter of Western genre scenes, beginning in 1838, and sold many of these works through the newly established American Art-Union.[26] Bingham's last exhibition in New York occurred in 1852, after which he returned to the southern Midwest, traveling constantly through the region as well as up and down the East Coast. In the late 1850s he visited Europe twice, staying mainly in Paris and Düsseldorf. For the last twenty years of his life, he settled permanently in the Midwest, combining an on-again, off-again political career with work as a painter.

Bingham's scenes of life on the river invariably show men relaxing in a still and humid atmosphere, suffused with a soft, golden light. *The Trappers' Return* (**fig. 23**), painted in New York and originally exhibited as *Dug-Out*, was a reworking of an 1845 composition, *Fur Traders descending the Missouri*

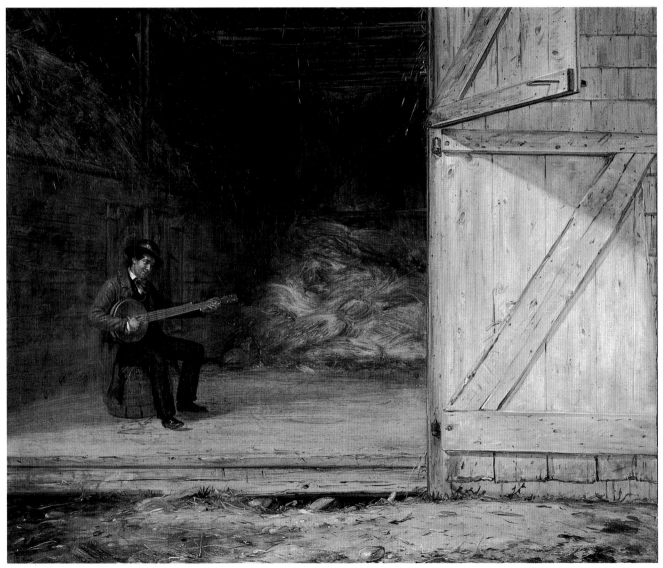

22

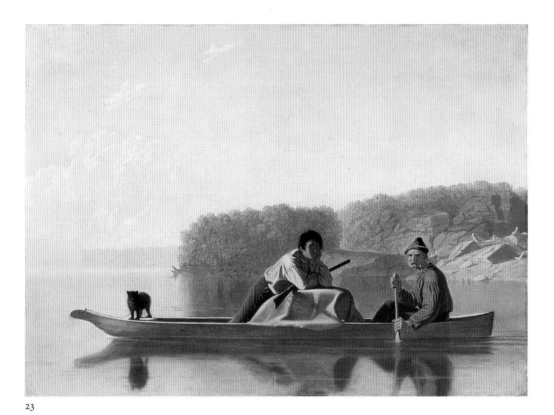

23

(Metropolitan Museum of Art, New York), originally exhibited as *French Trader and Half-Breed Son*. In *The Trappers' Return*, Bingham takes to extreme the saturated atmosphere and languid figures. The man and boy establish eye contact with the viewer, as does the bear cub chained on the prow. The small plume of smoke from the old man's pipe and the gentle wake at the stern of the boat provide the only sense of movement in an otherwise motionless scene. It is not difficult to see this reworking of the river theme—and *The Trappers' Return* was one of his last efforts in this genre—as something of an elegy; a final visit to a world that Bingham himself knew was on the verge of extinction.

While many of Bingham's scenes are set in the bright outdoors, either against the wide Missouri of his earlier river scenes or in the "town square" of social and political gatherings, on occasion, as in *The Checker Players* (**fig. 24**), of 1850, he turned to darker interior settings. The painting is also unusual in the close-up relationship of the three figures to the picture plane. Bingham may have been trying to capture the congenial companionship of three friends relaxing, presumably at the end of a day's work, while emphasizing the intellectual aspect of this form of recreation. A writer who saw the work in progress commented "the force and power of the artist, in catching and portraying the position and expression, is finely developed. This, when completed will by itself be lasting evidence of [Bingham's] talents."[27] But when Bingham offered the work to the American Art-Union in 1851, they were not impressed and declined to take it, precipi-

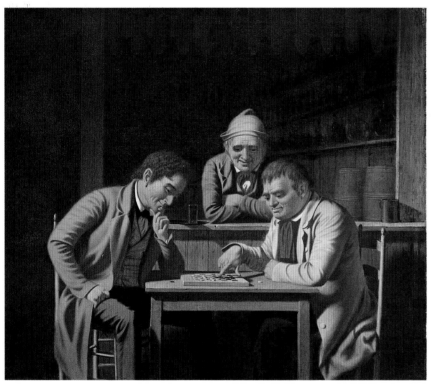

24

tating the artist's break with them shortly before the Union was itself declared illegal.

The Union's rejection of *The Checker Players* probably had something to do with Bingham's high asking price of seventy-five dollars. It may also have had something to do with the ungainly demeanor of the three men and claustrophobic composition, characteristics that would have been compared unfavorably with the work of one of the Union's latest discoveries in genre painting: Richard Caton Woodville. Born in Baltimore to an established family of "good English stock,"[28] Woodville was trained abroad and, with one exception, painted all his best-known works in Europe. Woodville showed an early talent in drawing and, having overcome his father's doubts about his chosen career, left the United States

in 1845 with Italy as his destination. Instead, he stopped in Paris and then went on to Düsseldorf where he stayed until 1851. He sent his work back to his father, William Woodville V, who sold it through the American Art-Union and, in some cases, had engravings made from the paintings. After a brief trip home in 1851 he returned briefly to Paris, then moved to London, all in the same year. He died in London in 1855 from "poisonous effects of morphia, medicinally taken."[29] But if Woodville's locations seem markedly un-American, his subject matter was addressed exclusively to his "home" market. His early demise deprived America of a notable artistic talent and recorder of the American scene.

The Card Players (**fig. 25**), of 1846, was Woodville's first major artistic success. The painting became nationally

24
George Caleb Bingham
The Checker Players
1850
Oil on canvas
Gift of Dexter M. Ferry, Jr.
52.27

25
Richard Caton Woodville
The Card Players
1846
Oil on canvas
Gift of Dexter M. Ferry, Jr.
55.175

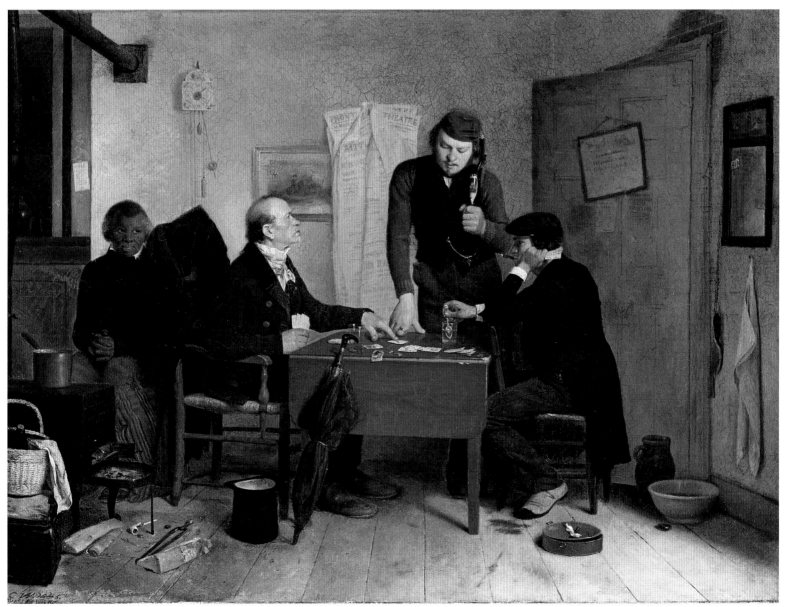

25

26

26
Eastman Johnson
In the Fields
Ca. 1878–80
Oil on board
Founders Society
Purchase, Gift of Dexter
M. Ferry, Jr.
38.1

renowned through exhibitions at several East Coast venues and the widespread dissemination through the Art-Union's 1850 engraving. The theme, common in European painting since the seventeenth century, is that of a stolid citizen being rooked by a cardsharp. Whereas earlier works focused more on the psychological drama, Woodville weaves a detailed tapestry capable of more than one interpretation. The bald-headed man, seated four-square in an armchair, points to a card on the table while looking up at a pipe-smoking German immigrant, as if asking for an opinion. On the other side of the table, a wily-looking younger man, cheroot aggressively turned up from his jutting jaw, cap pulled down over his eyes, sits on a chair drawn up back to front, grasping his cards at his shoulder. What looks like the corner of a playing card protrudes from under his thigh. Does the German know what is going on? Is he, as is usually the case in seventeenth-century renditions, an accomplice, or is he, too, being used by the purported cardsharp. His proximity to the younger seated man could suggest the former, but at least one contemporary observer thought otherwise: "the third person is a German, evidently a newly arrived emigrant [*sic*], who is called upon to judge the matter, and who is somewhat perplexed by the difficulty of the case."[30] In the corner of the room behind the older man, an African American is seated warming his hands by the stove. Though marginalized by his position, the black man—presumably the card player's servant or slave—seems to know more about what is going on than his master, as his sideways gaze implies.[31] Surrounding the men are any number of carefully painted still-life objects, most of which can be construed to have a moralizing purpose. One broadside on the door advertises a stagecoach service, reinforcing the obvious notion that the older man, with his furled umbrella and mud-caked boots, is a traveler. Another broadside refers to the Baltimore Lock Hospital, a charlatan institution dedicated to the cure of ills supposedly induced by masturbation (like gambling, a form of self-abuse?). Between the card players hang notices advertising a theatrical production of a

"Battle," and hanging directly behind the older man's head is a framed print of an equestrian conflict. Above the traveler a pendulum wall clock, showing seven past four (whether a.m. or p.m. is impossible to determine), ticks the seconds away. Has the traveler missed his coach or is he just wasting his time, on his way to a hell symbolized by the fire in the stove and the broken pipe beneath it? With this kind of reading possible, it is easy to see why a narrative-loving nation would take to the expatriate's careful delineation of a rapidly growing nation on the move. It is also understandable why the Art-Union should prefer *The Card Players* to Bingham's *The Checker Players*.

Following his early death, Woodville's potential as the leading American genre painter of his day was fulfilled by Eastman Johnson. Having trained in Europe (Düsseldorf, Paris) and practiced as a portrait painter in both the Netherlands (The Hague) and America (Boston, Washington, D.C., Cincinnati), Johnson burst onto the national scene with the exhibition of his 1859 painting *Negro Life at the South*, exhibited at the National Academy of Design, New York, that same year. He built on this success with sympathetic depictions of newly freed slaves and other scenes drawn as he followed the Union Army during the American Civil War (1861–65). After 1869, Johnson summered on Nantucket Island, Massachusetts, and derived much of his subject matter for his genre scenes from his observation of such gentle, rural activities as cornhusking and cranberry picking. *In the Fields* (**fig. 26**) probably dates from around 1879 when, as the artist wrote, "I have been industrious enough here. I was taken with my cranberry fit as soon as I arrived…and I have done nothing else."[32] The artist, as was noted by his earliest biographer, "preaches no ugly of discontent, as does so much of the contemporary French and Flemish art of this genre…there is no 'cri de la terre' arising from the cranberry marshes or his hay stuffed barns."[33] What is unmistakably French in the painting is the fluently handled broad brushstroke and use of the ground paint as part of the overall treat-

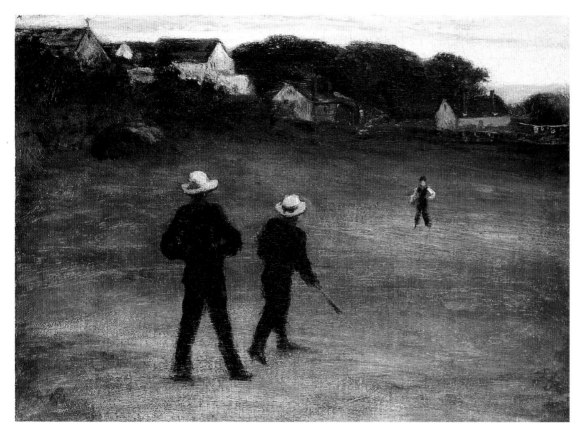

27

27
William Morris Hunt
The Ball Players
Ca. 1877
Oil on canvas
Gift of Mrs. John L.
Gardner
07.12

ment. Also French is the dramatic contrast between light and shadows, an occasion for Johnson to clearly put into practice the maxims of his teacher in Paris, Thomas Couture, who advised artists to "establish what I call 'dominants' for light and shades" and use them as "tuning forks" to establish the other values.[34] Further in keeping with French Academic traditions was Johnson's attitude to his own sketches; he never exhibited them, even though, as one obituary notice asserted, "he liked to keep his sketches, and knew they were better." Eastman's affection for *In the Fields* is clear from its presence, framed, in his studio, as shown by a photograph taken in the year of his death.[35]

William Morris Hunt was another student of Couture. According to Hunt's biographer and student, Helen Knowlton, Hunt, as a teacher in Boston, also stressed that "'values' were the all in all; that everything existed by its relative value of light and shade."[36] She also described his working process at the time *The Ball Players* (**fig. 27**) was created:

Hunt would…take a camp-stool and a block of charcoal paper, and, with a stick of charcoal, seize the salient points of the subject to be rendered. While thus engaged the assistant would arrange an easel and select necessary paints and brushes. Sometimes he was told to 'lay-in' the first painting, —reproducing the effect of the charcoal-sketch, while

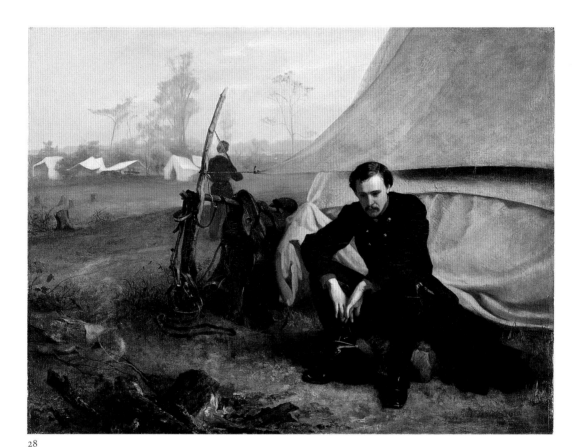

28

28
George Cochran Lambdin
At the Front
1866
Oil on canvas
Founders Society
Purchase, Director's
Discretionary Fund
59.314

Hunt would watch intently for the right moment to come, when he would seize palette and brushes, and perhaps complete the picture in one sitting. [37]

Five figures are featured in the charcoal sketch for *The Ball Players,* but only three—the essential pitcher, batter, and catcher/umpire—appear in the painting, finished in 1877. The dark-clad figures are seen against a field of brown paint. A row of houses and trees, surmounted by a strip of pale sky, runs across the top of the canvas. With its radical simplification and flattened composition, *The Ball Players* was a bold statement for American painting at this time.

The Civil War provided subject matter for American artists

that they would continue to exploit until long after the actual conflict had ceased. The battles themselves appear to have held relatively little attraction for artists, most of whom preferred to focus on the psychology of soldiers during the long, often boring, periods between action. George Lambdin, who seems not to have served himself, may have been inspired to depict young officers by the example of his brother, who served in the Union Army of the Potomac and rose to the rank of colonel. The last in a series of four paintings featuring the same young officer, *At the Front* (**fig. 28**) may represent a moment not long before battle is about to be engaged. On the back of the painting, Lambdin has written, "from studies

made on the Rapidan, 1864–65." On May 4, 1864, the Rapidan River in Virginia was crossed by General Ulysses S. Grant, recently appointed commander in chief of all the Union armies, as he led more than one hundred thousand men to attack Robert E. Lee's Confederate troops. The ensuing Battle of the Wilderness, which lasted from May 5 to May 7, resulted in a total of more than 25,000 casualties killed, wounded, or missing. These events would have been fresh to any viewer in 1866, who, aided by the title, could easily imagine that this cavalry officer, fully dressed, saddle and bridle nearby, is meditating on hearth and home as he readies himself for battle. And, as *At the Front* is the last of the series, the dying fire might even be seen as foreshadowing the soldier's own end. Whatever the niceties of the symbolism and psychology, when exhibited at the Academy of Design in 1866, Lambdin's efforts were rudely handled by the critics. Typical were the comments of a reviewer writing for the *Round Table*, who compared Lambdin's work unfavorably to that of his contemporary, Winslow Homer:

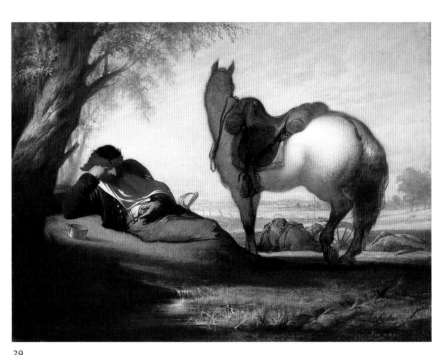

29

If it is not too late for George Lambdin to learn, he might be taught a few truths by Mr. Homer's mode of study and unsentimental treatment of masculine themes. Mr. Lambdin's pictures, by their story connected with the war, are the most unmanly, the most unheroic, the most unsatisfactory of art and feeling that have ever come from the easel of a painter whose works have won our respect, sometimes our love.

Warming to this theme, the artistic armchair general goes on to attack *At the Front* specifically for being "too neat and trim in execution for the subject…it cannot be accepted as a rendering of the poetic side of camp life [!]…he must get into a more bracing medium…he must not be afraid of the rude and homely and virile."[38] Perhaps chastened by such criticism, Lambdin moved from Philadelphia to New York and the milieu of such other specialists in sentimental genre pieces as J. G. Brown and Eastman Johnson. In the 1870s he returned to the Philadelphia region, where he gradually

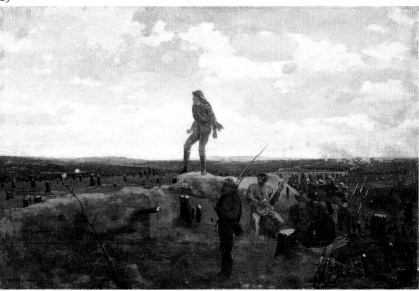

30

29
William Rimmer
Civil War Scene
Ca. 1870–71
Oil on canvas
Gift of Dr. and Mrs.
Sheldon Stern
73.103

30
Winslow Homer
*Defiance: Inviting a Shot
before Petersburg*
1864
Oil on panel
Founders Society
Purchase with funds from
Dexter M. Ferry. Jr.
51.66

abandoned genre scenes in favor, first, of pictures of pretty women in garden settings and, finally, floral still life.

A very different personality was William Rimmer. Born in Liverpool, to a man who claimed to be the rightful heir to Louis XVI, Rimmer was taken to America in 1818 and never returned to Europe. Partly educated by his father and partly self-taught, Rimmer extended his vocation beyond painting to include physician, poet, musician, and composer. Much of his work addressed historical and literary subjects (Achilles, Macbeth, King Lear), focusing on moments of dreadful decision making. *Civil War Scene* (**fig. 29**) is one of a group of paintings created several years after the end of the conflict. Whereas other artists concentrated on specific events and imbued them with a sense of coherent narrative, Rimmer's work is all ambiguity and his generalized forms encourage a symbolic gloss. By a running stream, tin cup at his side, a wounded Union soldier looks at his watch while the nearby horse looks toward the fallen Confederate soldier and horse in the middle distance. Time, the Waters of Life, Death on a White Horse? It is impossible to tell but seems likely that Rimmer's intent was as much allegorical as narrative.

Also self-taught was Winslow Homer, whose precocious talent led him first to a career as an illustrator for various magazines specializing in genre scenes. By the end of his life he had established himself as one of America's premier artists, a masterful watercolorist and painter of powerful seascapes. It was with his scenes from the front during the Civil War that Homer made his transition from primarily magazine illustrator to primarily painter. As a "special artist" for *Harper's Weekly*, Homer's pass gave him access to the combat zone at various times between 1861 and 1864. It has been generally accepted, from the title, that *Defiance: Inviting a Shot before Petersburg* (**fig. 30**), of 1864, depicts the Confederate side of the siege of Petersburg, Virginia. It shows a daredevil soldier standing erect on the top of a breastwork to draw the sharpshooter fire from the Union positions a couple of hundred yards away. There are several accounts of

this kind of event, including one that describes a duel with rival sharpshooters shooting at one another until one dropped.[39] In Homer's scene, however, the Confederate is unarmed and shouts and gestures in a manner closer to a similar event described elsewhere:

One of the Union marksmen saw by means of his telescopic rifle a man on the ramparts of Yorktown, who amused himself by making significant gestures towards the lines…The distance between them was so great, that the buffoon supposed he was safe; but the unerring ball pierced his heart, and he fell inside the works.[40]

The two puffs of smoke emanating from the distant Union lines indicate that Homer may have captured the final split second of the daredevil's life. The presence of a black man playing a banjo has caused discomfort and much comment from Homer scholars. The man's face is alarmingly like that of a white minstrel using "burnt cork" to make his face black. His frivolous behavior seems oddly at contrast with that of the bold soldier and the stalwart sentry. But such diversions are common to armies of all ages, and the Civil War was no exception. Given that some of Homer's other Civil War scenes can be read in a moralizing fashion comforting to Union supporters, the three men in *Defiance* may be taken to represent "the folly—poignant perhaps, but nonetheless folly—of the Southern side in 1864, as an ill-prepared lot not up to the military component of the Army of the Potomac."[41]

After a year-long stay in France, Homer returned to New York in 1867 and began to work in ways that suggest strong parallels to the advanced practices in France at that time. Homer painted variants of the same subjects repeatedly, often scenes drawn from modern life but lacking in anecdote and, perhaps most remarkably, painting *en plein air*, not just preparatory studies, but the finished works themselves. This last activity, one he practiced at least as early as 1864, must have been especially significant to Homer. Usually silent about all aspects of his artistic practice—physical and philosophical—Homer actually exaggerated his *plein air* methods.

"Many of [my] finished works," he is thought to have told the critic George W. Sheldon, "were painted out-doors in the sun-light, in the immediate presence of Nature."[42] In keeping with the outdoor emphasis, many of Homer's paintings after his return from France are of rural scenes: "The representation of energetic boys and comely girls offered up to an audience still in the process of healing the psychic wounds inflicted by the Civil War."[43]

Detroit's *The Dinner Horn* (**fig. 31**), of 1873, is the last of several versions of a scene first painted in 1870 and reproduced the same year as a wood engraving in *Harper's Weekly*. A writer in 1872 could have been referring to existing and subsequent variations when he described the scene as "a farmer's daughter and maid of all work just from the kitchen…blowing the dinner horn" for workers in the fields.[44] Earlier versions showed the young woman standing fully in the open, her skirt being blown by a middling wind, while the Detroit painting has the woman standing on a vine-clad porch. Edgar Richardson, who, as director, acquired *The Dinner Horn* in 1947, wrote of "the matchless freshness and naturalness of feeling, which gives the observer the sense of being there in person…feeling the warmth of the sun…the hum of summer…It is the product of careful study…that result[s] eventually in an image whose art totally conceals the art by which it was created."[45] This "artlessness," a feature discernible in much of the work under consideration here, was valued by Homer and his audience. One commentator, writing for *The Nation*, openly fretted about the consequences of Homer's trip to Europe: "we are sorry to hear it. His work is delightful and strengthening, and promises much: and although it may well be improved in many respects by his residence and study abroad, it is much more likely to be injured."[46]

Homer's stay in France clearly changed his art and for the better, moving it to a new level where the observation of people in nature was distilled into freshly painted scenes, full of visual pleasure and subtle ambiguity. Like the French Impressionists, he preferred locations where modernity and nature collided. Homer's scenes of women at the seaside, or on ponies at well-known tourist sites, are unlike anything else in American art of the time and received an equal amount of favorable and baffled criticism. A second trip abroad, when he spent the best part of two years (March 1881–November 1882) in the fishing village of Cullercoats on the northwest coast of England, also precipitated a change in his art. The direct influence of English art on one of America's greatest artists is not something readily conceded by American writers:

Indeed, there is danger in seeing the English trip too much in isolation…In Gloucester [Massachusetts] during the summer of 1880 he began to change the look of his work in watercolor…he had already experimented with bringing these same changes to his oils. Having also determined to change his subject matter, Homer went to England, found new subjects, and then began working following his usual procedure.[47]

31
Winslow Homer
The Dinner Horn
1873
Oil on canvas
Gift of Dexter M. Ferry, Jr.
47.81

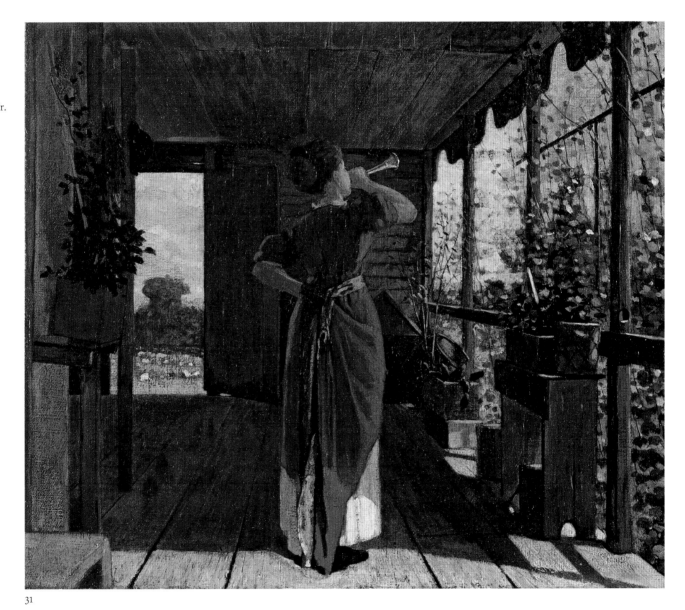

31

From Sea to Shining Sea:
Landscape as the National School

Frederic Edwin Church, detail of *Cotopaxi,* 1862 (fig.35)

That landscape should take so long to establish itself as the premier form of American painting may, at first, seem surprising. American artists were regular visitors to Britain where, by 1820, the genius of Turner and Constable, as well as the talents of many others, had amply demonstrated the range and flexibility of landscape painting. These artists had built on Edmund Burke's theory of the Sublime that stressed the literally "awe-full" power of Nature and its ability to induce a pleasurable sort of horror; ideas that had been given expression in the Welsh mountain scenes painted by Richard Wilson as early as the mid-eighteenth century. And landscape was, surely, free of any suspicion of aristocratic leanings. Part of the problem for American painters, ironically, was that it was *too* free of such tendencies. With the young state trying to avoid the pitfalls of the older society with which it had so dramatically parted company, there was considerable concern that the art it sanctioned be commensurate with the noble task of building a new and better nation.[48] Though a soldier in the Continental Army and a man of drive and originality, Charles Willson Peale only reflected the prevailing theories of Sir Joshua Reynolds's Royal Academy when he penned his admonitions against his son's still-life paintings. Landscape was, if anything, lower down on the scale and, therefore, even less apt material for heroic expression. And when American artists looked at European landscape painting, they mainly saw well-tended fields interspersed with ancient buildings set against low mountains. Beyond their immediate backyards in America, artists were confronted with a wilderness that defied traditional artistic conventions. Early American pioneers in the genre, such as Thomas Birch or Thomas Doughty, who tried to meld the indigenous topography with compositional devices of Claude Lorrain or Jacob van Ruysdael, missed the mark.

In 1816, at an address to the American Academy of the Fine Arts, based in New York, DeWitt Clinton, governor of New York, pointed out to all assembled the unprecedented opportunity presented by their great country:

And can there be a country in the world better calculated than ours to exercise and to exalt the artistic imagination—to call in to activity the powers of the mind, and to afford just views of the beautiful, the wonderful, and the sublime? Here Nature has conducted her operations on a magnificent scale: extensive and elevated mountains—lakes of oceanic size—rivers of prodigious magnitude—cataracts unequaled for volume of water—and boundless forests…covered with the towering oak and the aspiring pine.[49]

It is significant that the perspicacious governor stressed the need for "powers of the mind" and an artist with the imagination to develop a new aesthetic framework for a new landscape. At the time he gave this address, the nation lacked such a person, but this situation changed two years later when a seventeen-year-old immigrant stepped off a boat in New York harbor.

Thomas Cole arrived with his family from Lancashire, England, in 1818. His father was a failed textile printer, and Thomas himself had been trained as an engraver of woodblocks used for printing calico. He spent a year by himself in Philadelphia before joining his family in Steubenville, Ohio. Here he worked as a pattern designer and woodblock engraver in his father's wallpaper manufactory and, it is thought, absorbed the poetry and philosophy of William Wordsworth, Samuel Taylor Coleridge, and others from his sisters, who ran a school for girls. He received minimal training in oil painting from an itinerant painter known only as Stein. After a brief stay in Pittsburgh, where Cole developed his preparatory sketch methods, which were to be so important to his development, he stayed again in Philadelphia, from 1823 to 1825, and improved his oil painting technique through the study of Birch's and Doughty's works. In 1825 he burst onto the New York scene when three landscapes, placed for sale in a New York City shop window, were snapped up by three leading figures in the city's art circles. Cole had somehow, essentially single-handedly, evolved the framework needed to "tame"

32

the American wilderness. He combined the detailed study of natural forms with artistic license to modify the scene. Above all, like Wordsworth in *The Prelude*, he makes the artist and the viewer one and the same. The foreground is invariably gone; the viewer, feet cut away from under, is pitched into the canvas. Cole introduced to American painting the sense of vertigo induced by actually crossing the landscape.

His work was lauded from all sides. His audience felt he had captured the essence of their land, and, had he wished, he could have pursued a lucrative career fulfilling their desire for such topographical depictions. But Cole felt otherwise. Echoing Sir Joshua Reynolds, Cole believed that art had a duty to instruct. In 1829 he went to England to further educate himself and develop his theories. In Europe he studied and assessed the work of Rosa (to whom Cole was often com-

pared in America), Poussin, Ruysdael, and Claude. He rated Claude as "the greatest of all landscape painters: and indeed I should rank him with Raphael and Michael Angelo."[50] When Cole returned to America, he stunned his audience with a series of panoramic paintings that told stories of the rise and fall of empire and the journey of man through life. They combined the detail and complexity of his own landscape formula with the poise of Claude (which he happily conceded) and the dramatic hyperbole of his English contemporary John "Mad" Martin (which he vehemently denied).[51] Cole mixed the production of these epics with that of more straightforward regional landscapes. By the time of his early death, he was regarded as the undisputed leader of a new national school in the making.

The Detroit Institute of Arts' painting *American Lake Scene*

32
Thomas Cole
American Lake Scene
1844
Oil on canvas
Gift of Douglas F. Roby
56.31

33

(**fig. 32**), of 1844, was produced soon after Cole returned from a second tour of Europe. Despite its small size, the painting demonstrates a number of Cole's hallmarks: the dead tree embedded in the island, the lack of foreground, a solitary figure—in this case an Indian—contemplating the scene, the vigorous brushwork and strong contrasts. But these features do not detract from the overall calm of the scene. Cole is thought to have exhibited *American Lake Scene* in New York in 1845. Reviewing the work, a writer for the *Broadway Journal* commented that "though small and unpretending [possesses] much of his character…it is the very poetry of solitude, and you hold your breath lest the echo of your voice should frighten you."[52]

Philadelphia-born landscape artist Thomas Doughty found himself eclipsed by the younger, more successful Thomas Cole, and, according to his own account, ignored by his colleagues. Doughty emerged from the indigenous craft tradition and was, at an early stage of his career, both a naval draftsman and leather currier. In 1816 he intensified his efforts to be a painter and by 1824 was a member of the Pennsylvania Academy. He numbered Thomas Sully among his close friends and was acclaimed for his landscapes. Between 1828 and 1838 he moved among Boston, Philadelphia, London, and New York, where he finally settled, dying there in poverty after a career of many ups and downs. *In Nature's Wonderland* (**fig. 33**) was painted in 1835, during Doughty's second sojourn in Boston, a time of relative success; it remains one of his best-known works. The strong contrasts of light and dark, rock and foliage, as well as the spiraling composition, are reminiscent of Cole's work, but

the solid foreground that anchors the whole is distinctly conservative. Critics, with whom he argued incessantly, took him to task for such conventional devices. Doughty responded that "every artist was at liberty to exercise his own taste, and indulge in either the free or the finical, the cool or the warm styles of manipulation of color."[53]

One of the purchasers of Cole's three "shop window" landscapes in 1825 was the successful engraver Asher B. Durand, who had reproduced renowned works by several contemporaries. In the 1820s Durand began to develop his own skills as a painter, first in portraiture, then in landscape. Inspired by Cole's example and encouraged by his friend and patron Luman Reed, Durand had become a full-time landscape artist by 1835.[54] When Durand tried his hand at epic landscapes, however, it soon became clear that he was temperamentally ill suited for such productions. He excelled in calm, bucolic scenes and critics urged him on in this area, predicting that if Durand devoted his attention to landscape alone "Mr. Cole will sooner encounter him as a rival than any artist now among us."[55] During his extended trip to Europe, Durand painstakingly studied the Old Masters and the modern English landscape artists. Combining lessons drawn from Constable with the enhanced color and panoramic ambitions of Cole, Durand developed a serene aesthetic that depicted a benign Nature, the product of a "Great Designer" and "fraught with lessons of high and holy meaning, only surpassed by the light of Revelation."[56] In *Monument Mountain, Berkshires* (**fig. 34**) there is no evidence of man, merely evidence of the cycle of nature: growing and rotting trees, a babbling stream set against a noble mountain range.

In some ways, the work of Cole and Durand represents one of the clearest manifestations of the ideas of the English critic John Ruskin, whose writings, when published in the United States in 1847, had immense influence on American landscape painters for several generations. Ruskin's insistence that "the representation of facts…is the foundation of all art"[57] and the general notion of the moral force of Nature were

commensurate with Cole's ideas. But Cole had already come to his own conclusions by that time, and Ruskin was often putting into words—albeit compelling ones—ideas already in the air. Ruskin's influence was more apparent on Durand. It was through Durand's own writings, published in his son's influential magazine *The Crayon* (1855–61), that many of Ruskin's ideas found currency.[58]

All the emphasis on the moral force of Nature, within a landscape seemingly untouched by humanity, did not mean artists were impervious to the changes caused by industrialization. Cole was greatly distressed when railroad lines were laid at the edge of his property but ignored their implications in most of his paintings. The same impulse that drove artists to paint on remote mountaintops and beneath great waterfalls was already giving birth to a tourist industry for individuals who were, in many cases, identical with the artists' customers. Alongside the viewer's sense of pride and awe in their American landscape—actual and painted—there existed a fear that this natural beauty lay on the verge of despoliation.

Cole and Durand are considered to be the founders of what is referred to today as the Hudson River School—with Cole given primacy.[59] There has been considerable debate about the usefulness of the term, but it is generally accepted that essential artistic tenets evolved by Cole, and further developed by Durand, inform the works of artists as different as Frederic Church and Martin Johnson Heade. Whether drawing inspiration from the Andes of Ecuador or the meadows of New Jersey, the Hudson River painters combine a meticulous painting technique with a palpable awe of Nature and, usually, a panoramic format.

Though praised in many quarters, both Cole and Durand's technical abilities as painters were questioned in their own lifetimes and harshly criticized subsequently. In the case of Cole, his grandiose aims in particular were deemed impaired by infelicities of touch; his insistence on epic themes inclined toward melodrama. No such flaws marred the work of Frederic E. Church, who is regarded as the foremost painter

34
Asher B. Durand
Monument Mountain, Berkshires
Ca. 1855–60
Oil on canvas
Founders Society
Purchase, Dexter M.
Ferry, Jr., Fund
39.6

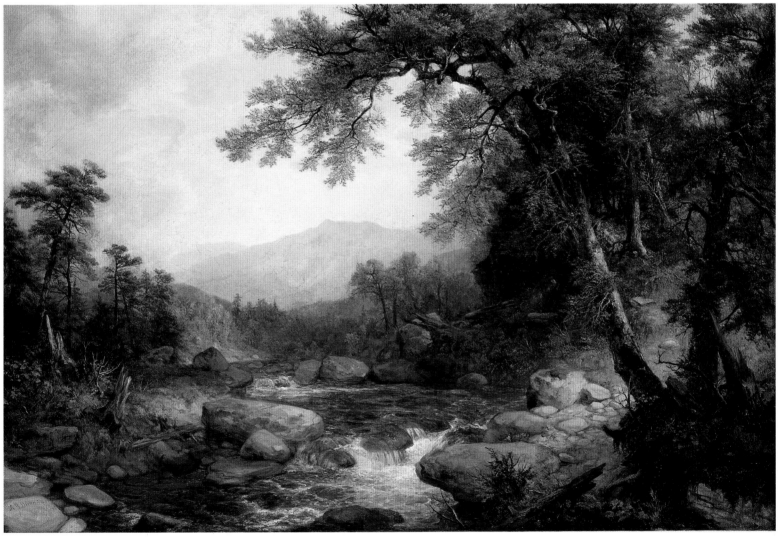

34

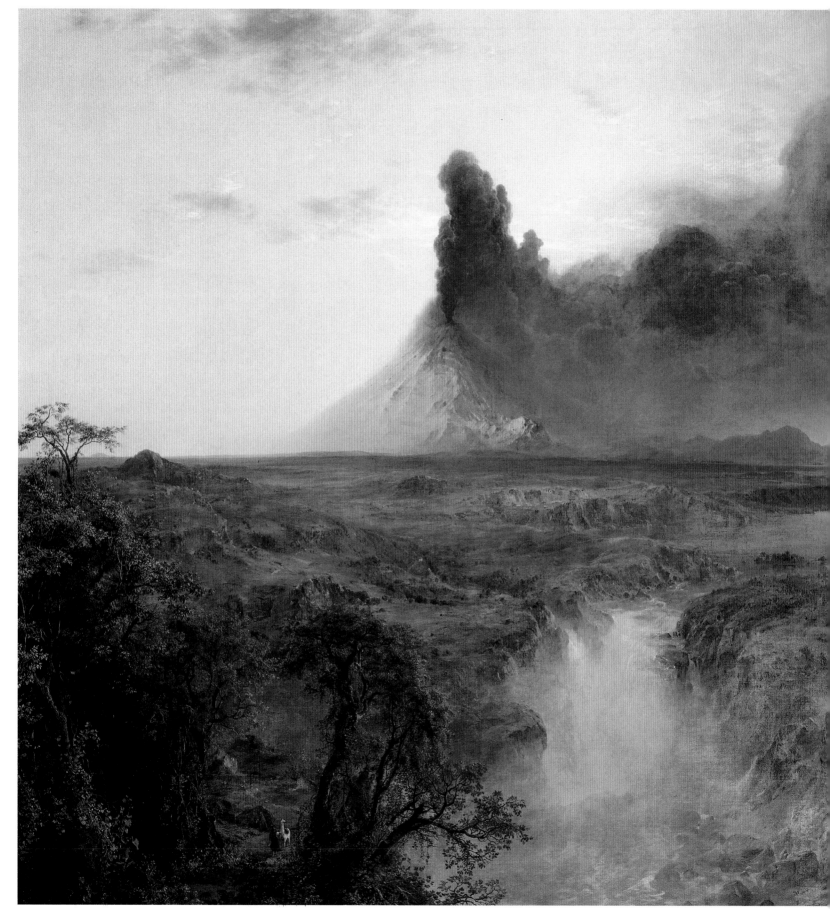

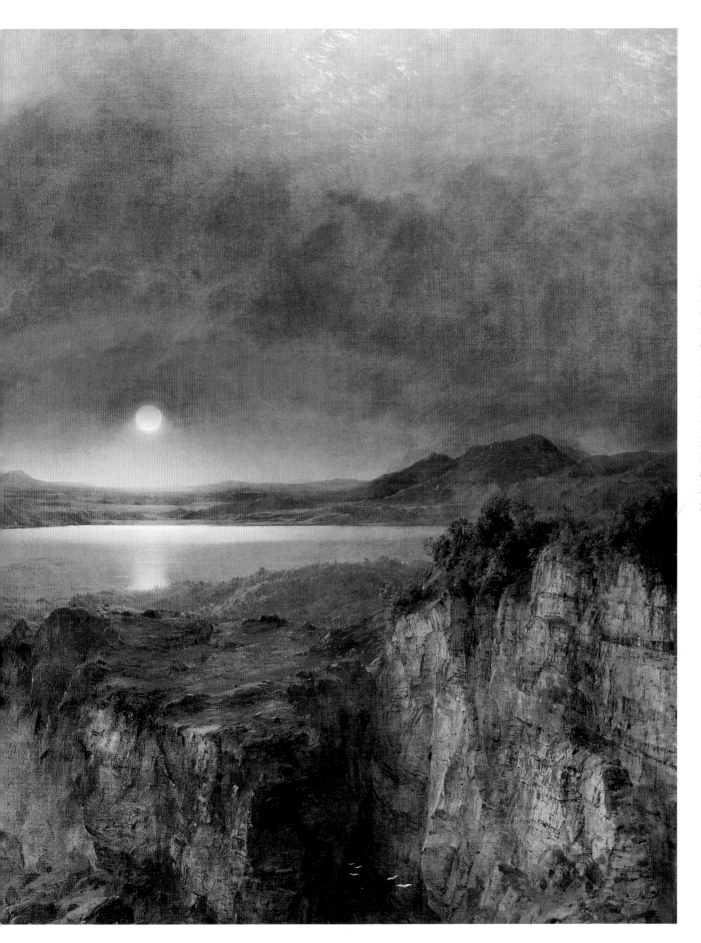

35
Frederic Edwin Church
Cotopaxi
1862
Oil on canvas
Founders Society
Purchase, Robert
H. Tannahill Foundation
Fund, Gibbs-Williams
Fund, Dexter M. Ferry,
Jr., Fund, Merrill Fund,
Beatrice W. Rogers Fund,
and the Richard A.
Manoogian Fund
76.89

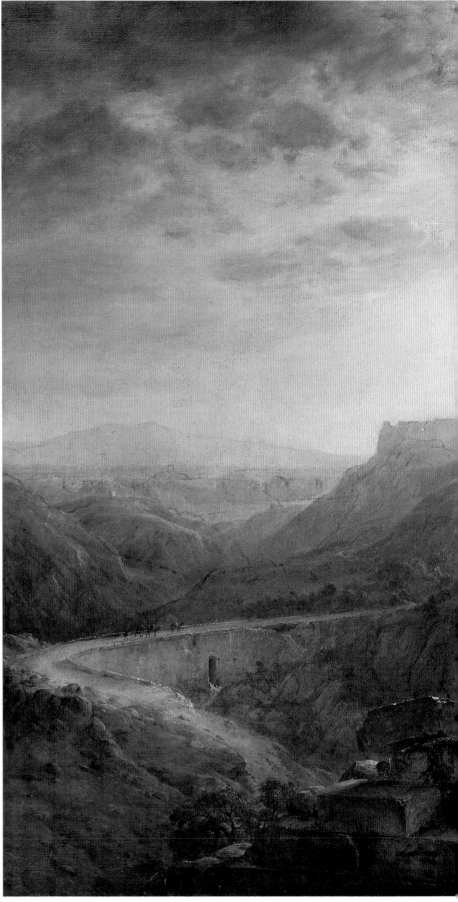

36
Frederic Edwin Church
Syria by the Sea
1873
Oil on canvas
Gift of Mrs. James F. Joy,
1910
10.11

of the second generation of the Hudson River School and,
perhaps, the finest of all. Coming from a wealthy back-
ground, he was also precocious. Within a year of being taken
on, at age eighteen, as a pupil by Cole, he was exhibiting at
the National Academy of Design. His family wealth enabled
him to travel widely and his South American paintings had
established his reputation by 1855. His 1857 *Niagara*, when
seen in London, was praised by John Ruskin as proof that
American art had at last reached international stature.

Cotapaxi (**fig. 35**) was painted after Church's second visit to
Ecuador in 1857 and embodies all that is essential in his work.
His readings of John Ruskin and the great naturalist
Alexander von Humboldt had caused him to travel widely,
and the Andes, in particular, where he followed Humboldt's
footsteps, proved particularly fruitful. Drawing on copious
sketches and notes made while traveling, Church forged a
large picture style, which distilled Cole's human narrative
and epic approach to a purer essence. In fact, Church
removed human references from his canvases almost com-
pletely. What he presented was an astonishing array of natu-
ral effects, rendered with precision and flair on a scale
hitherto confined to European history painting and best
known from the French salons of the eighteenth and nine-
teenth centuries. In *Cotapaxi* the viewer is suspended over an
abyss, confronted by smoke and mists, a burning sun, and
dramatic effects of light. Where Cole had felt free to manipu-
late light and color, Church held to a Ruskinian concept of
fact, and however extreme some of his compositions may
seem, they were always based on close observation. He may
have selected and assembled spectacular effects that verged
on the improbable, but his deeply held conviction that God
was made manifest in Nature precluded the possibility of
exaggeration or distortion.

The fanciful composition of *Syria by the Sea* (**fig. 36**), of
1873, stands in contrast to the verisimilitude that underpins
Cotapaxi. Produced following a trip to the Mediterranean in
1867–69, *Syria by the Sea* depicts the ruins of a series of multi-

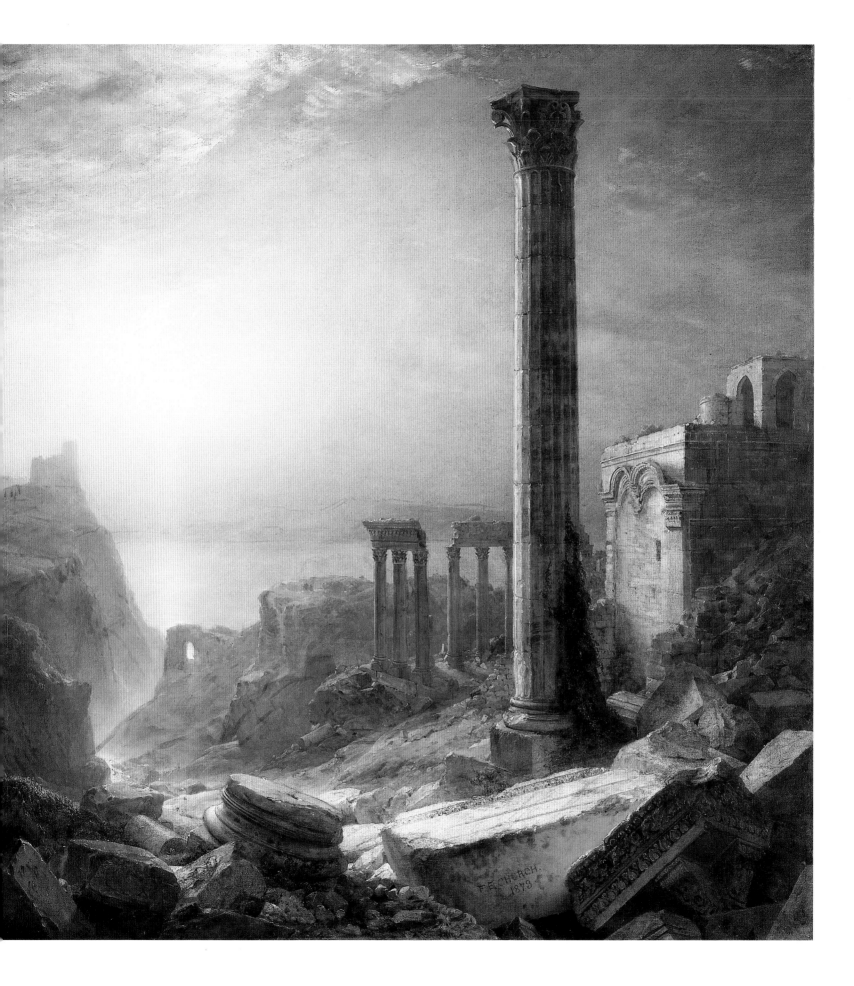

F. E. CHURCH.
1879

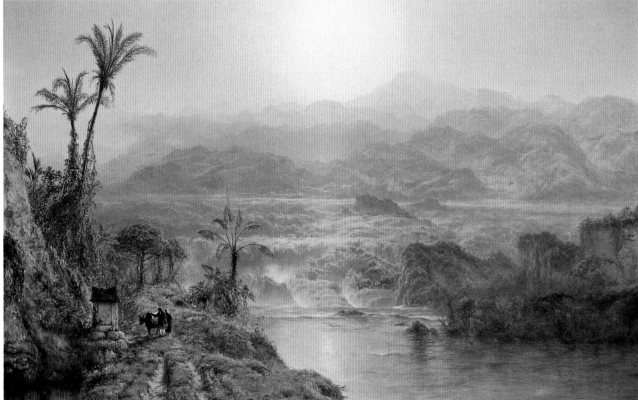

37

37
Louis Rémy Mignot
Morning in the Andes
1863
Oil on canvas
Founders Society
Purchase, Beatrice W.
Rogers Fund and funds
from Robert H. Tannahill
and Al Borman
68.345

38
Worthington Whittredge
Crow's Nest
1848
Oil on canvas
Gift of Mr. and Mrs.
William D. Biggers
41.12

ple civilizations in a single scene. With this work Church reverted to the venerable tradition of the *capriccio*—a fanciful assemblage of buildings in a landscape—as practiced by European artists over several centuries and embraced by Cole himself. Church's caprice puts together Greco-Roman, Islamic, and Romanesque architectural ruins, suggesting that all great civilizations crumble leaving nature as the only constant. The brilliant sun, set in a cloud-filled sky, eradicates much of the color and, in seeming to blind the viewer, recalls J. M. W. Turner's 1840 *The Slave Ship*, which Church could well have seen in London in 1867. *Syria by the Sea* may also be Church's response to *Desolation*, the final painting in Cole's

series *The Course of Empire*. But whereas Cole presented a generalized but basically classical empire and told his story over five episodes, Church distills the aftermath of several civilizations into a single composition. When the painting was exhibited at the Century Association most viewers followed the lead of a critic who understood and applauded *Syria by the Sea* as "noble and imposing." But at least one reviewer chided Church, a realist artist in a realistic age, for "plac[ing] imaginary ruins on a coast where we know there are no real ones."[60]

Accompanying Church on his second trip to Ecuador was Louis Rémy Mignot. Born to a prosperous French, Catholic,

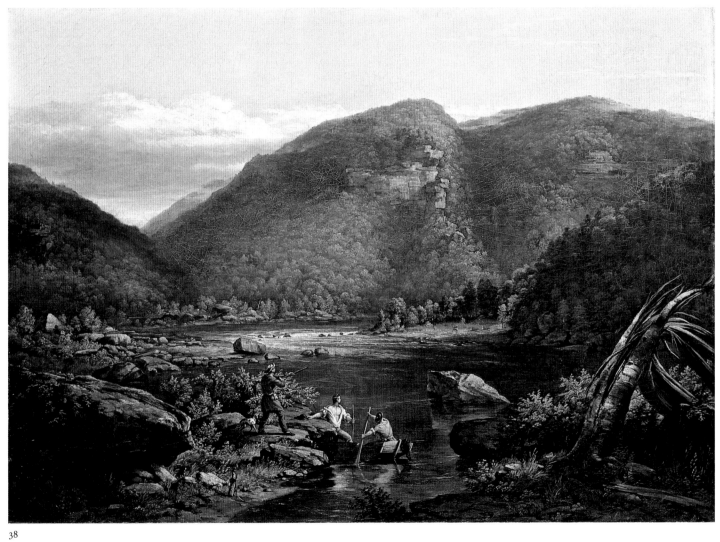

38

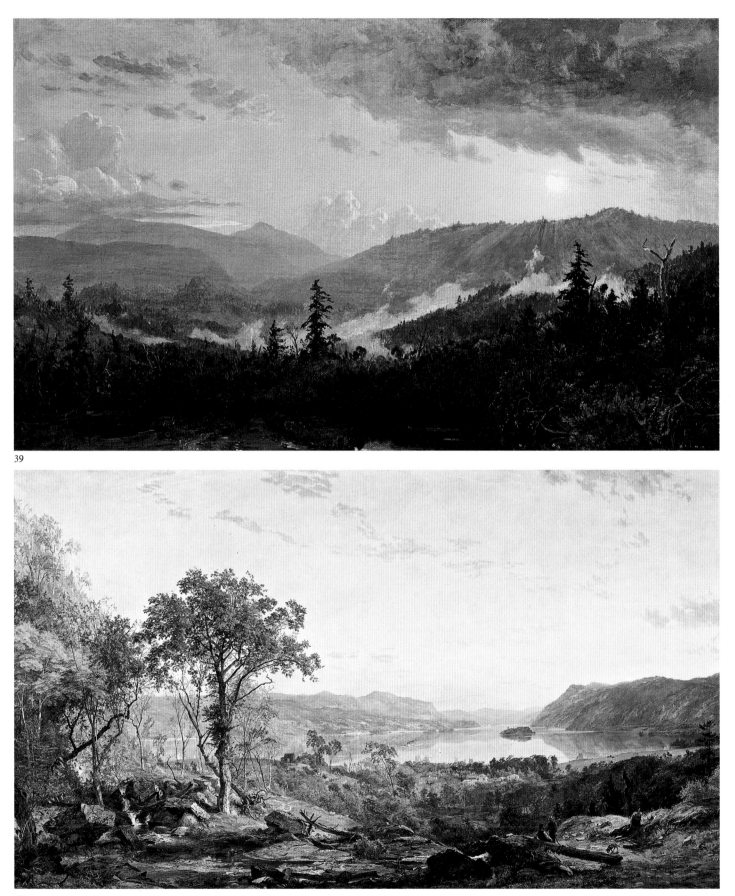

39

40

slave-owning family in Charleston, South Carolina, and trained in painting for five years in The Hague, Mignot's background was quite unlike that of the artists with whom he associated in New York after 1855. Initially producing landscapes based on terrain in New York, Virginia, Maryland, and Pennsylvania's Susquehanna River region, Mignot's work was transformed by his four-month journey to the Andes. For the rest of his career Mignot returned to the sketches made there to produce such lapidary works as the 1863 *Morning in the Andes* (**fig. 37**), where he depicts the Cordillera mountain area bathed in a soft light, the atmosphere heavy with moisture. It is, at the least, "the efficient delineat[ion] of tropical vegetation and light" noted by one early viewer.[61] A notable feature of all Mignot's Andean scenes are the attenuated palm trees. In *Morning in the Andes* two are prominently placed above a wayside shrine, a common enough feature in landscape paintings of Italian and other Roman Catholic countries. Here it has a special significance. Church and others viewed Mignot's South American landscapes as being implicitly about the Act of Creation. Mignot's insistent inclusion of the palm tree, long associated with the tree of life, in all Andean scenes encourages the notion that he was explicitly depicting a remnant of the original Eden that had somehow escaped the Deluge.

Actually painted in London, where Mignot had gone in 1862 to escape the tension of being a southerner in the northern city of New York, *Morning in the Andes* reflects the artist's increasing separation from the influence of Church and the growing influence of Turner, seen most notably in the pervasive haze. Exposure to Pre-Raphaelite painting further released his innate sense of color. Mignot found success in England and traveled to Switzerland and France. Caught in Paris during the Franco-Prussian War, Mignot returned to England in 1870, only to die of smallpox in Brighton.

Closer to home is the early work of Worthington Whittredge, well represented by *Crow's Nest* (**fig. 38**), of 1848. Painted before he left his native Ohio, it clearly shows the influence of

Cole's landscapes of the 1820s and '30s, depicting a land in the earliest stages of domestication. The exact location pictured is not known, but the topography itself, as well as the "leaf by leaf" style of realism, strongly suggests the Ohio River Valley and the school of painters who dwelt there. In the 1840s and '50s, Cincinnati briefly emerged as a powerful commercial and cultural center with aspirations as a new "Athens of the West." It was not to be, and in 1849 Whittredge himself began a ten-year-long sojourn in Europe, after which he moved to New York. There he had a successful career at the center of the American art world, which was crowned by his appointment as president of the National Academy of Design.

New York-born Jasper Cropsey emerged from a hardscrabble background to become an architect for five years before taking up painting. By 1844 his work had already earned him election to the National Academy, and in 1847 he began a two-year stay in Europe. In Italy he stayed at Cole's old studio and traveled through the Campagna, expanding his landscape vocabulary. An extended stay in London, from 1856 to 1863, resulted in considerable artistic success and accolades from Queen Victoria herself. Exposure to Turner and the Pre-Raphaelites influenced Cropsey's use of color, and, at the very least, his career gives the lie to the oft-repeated assertion that most Hudson River painters avoided European artistic influences as much as possible.[62] If anything, the careers of Cole and all who followed him demonstrate an increasingly subtle and beneficial blending of American and European traditions.

Cropsey painted the oil study *Sunset after a Storm in the Catskill Mountains* (**fig. 39**) in London from studies he made five years earlier. Whether the mountains depicted are the Catskills in New York or the White Mountains of New Hampshire is not clear since Cropsey visited both areas in the year before he left for England. The study forcefully illustrates Cropsey's own mission "to give the delicate and evanescent beauty that every hour in the day presents itself in the sky."[63] Here the sky, an intense yellow, bracketed by

pinkish-orange clouds and mountains, is set behind a dark green foreground. This dramatic use of complementary and contrasting colors symbolized for Cropsey the oppositions of the natural world: darkness and light; storm and calm. In the sketch, a bear lumbers down the path that leads into the picture, but in the finished painting of 1861, made from this study, the bear had disappeared, displaced by settlers in a log cabin.

Indian Summer (**fig. 40**), the second largest painting ever made by Cropsey, is something of an ode to America. Painted one year after the end of the Civil War, it portrays New York's Hudson Valley in autumn, a season especially dear to northerners. The location depicted was one of enormous strategic significance during the War of Independence. It was here that an iron chain was strung across the Hudson River to prevent the British Navy's attempts to penetrate territory in the control of the Continental Army. Pictured in the middle ground is a white house, possibly George Washington's headquarters in 1782–83, from which flies an American flag. By the time Cropsey painted *Indian Summer,* this area attracted hordes of tourists who came north from New York City to visit the famous sites, in exactly the type of steamboat whose black smoke stains an otherwise golden landscape. Cropsey's vermilion foliage comprises accents in an otherwise serene composition, combining the pastoral landscape with the memories and hopes of a democracy that has just emerged from a searing national nightmare.

Although Alfred Bierstadt had established himself within the Hudson River circle as early as 1858, his career was determined by a trip to Colorado and Wyoming to acquire material for large-scale paintings, à la Church, of the American West. In this, he was successful beyond expectations. With a mixture of technical facility and business acumen, Bierstadt made his name synonymous with the Rocky Mountains and, following other trips to the West Coast, the Sierra Nevadas, Yosemite, and Oregon. If, in later years his work became formulaic and lost its immediacy, it was instrumental in raising the national consciousness and contributed to the movement to protect at least some of these new Edens.

The Wolf River, Kansas (**fig. 41**), painted on his first trip west, is set far from the thrusting peaks and wide valleys usually associated with Bierstadt's work. It offers a rare glimpse of the less dramatic landscape that lies between the Missouri River and the Rocky Mountains, an area usually traversed without visual comment by nineteenth-century artists on their way further west. The artist painted from sketches he made during a two-week stay at Wolf River, but the degree to which the work represents a particular location is not clear. The composition is conventional and the main indication that it is an American landscape is the Native American village atop the riverbank. Reflecting an attitude typical of its time, Bierstadt wrote, "the figures of the Indians [are] so enticing, traveling about with their long poles trailing along on the ground and their picturesque dress, that renders them such appropriate adjuncts to the scenery…and now is the time to paint them, for they are rapidly passing away; and soon will be known only to history."[64]

While Church, Bierstadt, and others traveled immense distances to accumulate material for their panoramic vistas, another group of painters associated with the Hudson River School generally stayed on the eastern seaboard, where they developed a very different aesthetic. Often described as "Luminists," artists such as John Kensett, Sanford R. Gifford, Fitz Hugh Lane, and Martin Johnson Heade took as their main subject matter the sea and the sky at moments of extreme stillness, rendered on a small scale. The intensely contemplative mood of these works has encouraged comparisons with the poetry of Ralph Waldo Emerson and the transcendentalist movement, and it is tempting to see the small, meditative paintings as the other side of the outward-looking, expansionist impulse, which inspired the larger salon-style works of Church and Bierstadt. The Luminist God is that of the still, small voice that came after the sound and fury.

41
Albert Bierstadt
The Wolf River, Kansas
Ca. 1859
Oil on canvas
Founders Society
Purchase, Dexter M.
Ferry, Jr., Fund
61.28

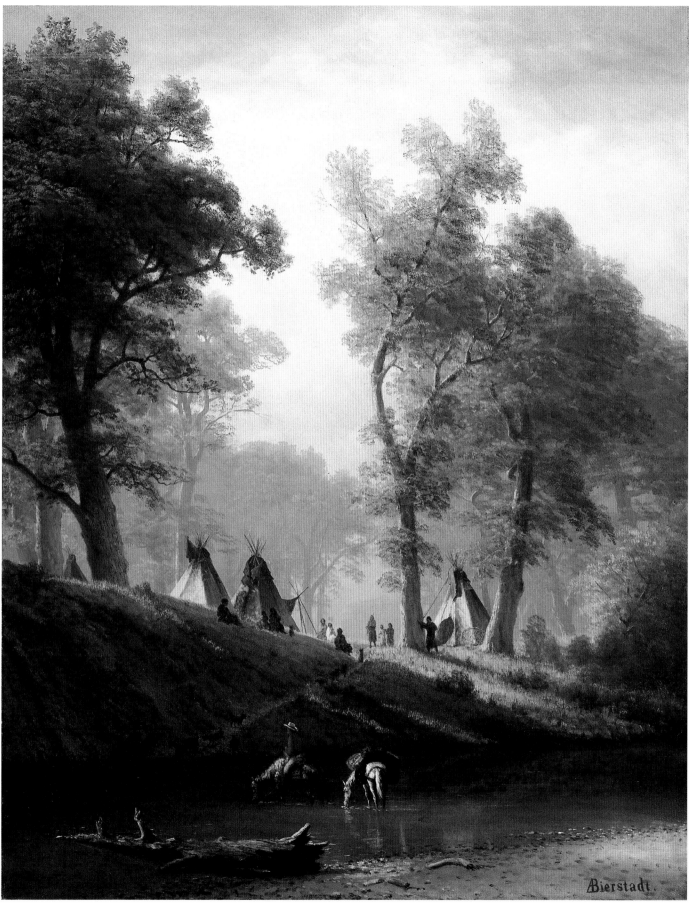

Bierstadt.

41

42

42
Martin Johnson Heade
Seascape: Sunset
1861
Oil on canvas
Founders Society
Purchase, Robert H.
Tannahill Foundation
Fund
1995.26

43

43
Martin Johnson Heade
Sunset
Ca. 1880
Oil on canvas
Founders Society
Purchase, Dexter M.
Ferry, Jr., Fund
46.135

44

44
Martin Johnson Heade
*Hummingbirds and
Orchids*
1880s
Oil on canvas
Founders Society
Purchase, Dexter M.
Ferry, Jr., Fund
47.36

Although a close friend of Church, Martin Johnson Heade was a distinctly different personality, with his own theories about art and life, which gained him a reputation for eccentricity in artistic circles. Initially trained by the Quaker "folk" or primitive artist Edward Hicks, Heade decided around 1860 to concentrate on landscape and still life. He traveled widely (as did other Luminists whose work focuses on the Northeast) and changed his city of residency regularly but was consistent in his pursuit of three basic themes: coastal salt marshes dotted with haystacks, the sea and the sky, and hummingbirds with flowers.

Seascape: Sunset (**fig. 42**), of 1861, vividly illustrates Heade's own ideas about "contrasts" and "doubles" (the pen name he used for his poetry and writings on art was "Didymus," from the Greek *didymous* meaning twin or double). A brilliant red and yellow sky, simultaneously fiery and serene, sits above a dark and roiling sea. The only signs of life are the sails of two vessels on the horizon and two seagulls flying a few feet above the waves. Critics at the time did not like the work, finding the combination of tranquil sky and wind-whipped sea incongruous. One wrote:

> Perhaps we are wrong in supposing that the artist is not true here to nature; but if he is, it is only in some exceptional mood…in that case the effect he has produced can only be exceptional, and therefore, in the main, untrue. It is a pity that this should be so in a work in which there is really so much beauty and so much that is new.[65]

Given Heade's temperament, it is indeed likely that he was recording—or concocting—an "exceptional" moment. More recently, scholars have sought to connect Heade's work to the use of sea and shipwreck imagery by writers, politicians, and clergymen as the United States staggered toward civil war. "Completed in advance of the war's outbreak, *Seascape: Sunset*…can be understood as an allusion to the nation's changing fortunes as the new decade unfolded."[66]

Heade never tired of painting his salt marsh landscapes and the public never tired of buying them. His early work depicted the marshes of Massachusetts; later he painted those of New Jersey and Florida. A passionate environmentalist, Heade was concerned about industrialization and tourism and, in paintings such as *Sunset* (**fig. 43**), comments subtly on the interdependence of humanity and nature. The haystacks are the result of men harvesting the grass that grew wild in the marshes, an activity which could only occur when the tide receded. Cut and piled on platforms, the hay was used for fodder and straw. There is no sense of conflict in this work, simply a sense of time passing, as the sun sets, animals graze, and a solitary heron looks up, momentarily distracted from its patient vigil for prey.

Heade described his life-long fascination with hummingbirds as an "all absorbing craze," asserting that "there is probably very little regarding their habits that I do not know."[67] Inspired by this love and the example set by Frederic Church, Heade traveled to South America and the Caribbean—most notably Brazil and Jamaica—where he studied the birds in their tropical habitats. From these observations he created unusual paintings, combining individual species of the bird with particular examples of exotic plants. In *Hummingbirds and Orchids* (**fig. 44**), painted in the 1880s, Heade depicts a Cora's shear-tailed hummingbird perched on an orchid's leaf, commencing his courtship display for a female bird. The orchid, *Cattleya labiata*, grows out of a twisting tree trunk. Behind the flower and birds stretches a wide valley, beyond which rises a mountain range. The emphasis on diminutive life forms at the expense of grandiose landscape represents a remarkable reversal of established Hudson River School priorities.

Odd Men In and Out: Painting the Imagination

As the Hudson River School reached maturity in the 1860s and began its inevitable decline, very few artists within its circle escaped a dramatic diminution of reputation within their own lifetime. One who did—by a radical change of style that reflected his new personal philosophy and seeming response to the more modern, painterly fashions emanating from France—was George Inness. Inness was always viewed as different from his peers. Where they cultivated well-groomed urbanity, he projected anguished genius; where they were careful of their reputations and prices, he was rude to clients and left the finances to his wife. This was not a pose; inflicted with a nervous disorder, he was intense, ragged, and given to long metaphysical ramblings. To his patrons Inness was the very picture of the eccentric artist. For the last twenty years of his life he was "acclaimed as the greatest American landscape painter and one of the great modern masters. Art critics and patrons appreciated the qualities of Americanness, spirituality, and modernity in his landscapes."[68] His early paintings fall within the general scope of Hudson River School interests but also reflect the influence of Old Master paintings. Travel to France in the 1850s exposed Inness to the Barbizon school, and he began to move away rapidly from his fellow American landscapists. In the early 1860s he was introduced to Swedenborgism, a metaphysical philosophy, which confirmed Inness's belief that finding God in the landscape depended more on capturing its essence than its details.

Painted the year before his death, *The Lonely Pine* (**fig. 45**) is among his most minimal works. It is the product of an imagination released by intense concentration and observation of nature. The eponymous tree sits oddly off center against a soft green field and a brilliant red sky above. A large yellow patch of sky is mirrored in the field below, as if the ground itself were liquid. Although Inness benefited from the overall late nineteenth-century shift to an "Impressionist" style, he made no bones about his hostility to it as one of the many "shams" in art, inclined to present the viewer with "the original pancake of visual imbecility, the childlike naïveté of unexpressed

vision."[69] Although he stated that a work of art should "simply…reproduce in other minds the impression which a scene has made" upon the artist, he went on in the same essay to assert that "only when the moral powers have been cultivated do conditions exist necessary to the transmission of the artistic inspiration which is from truth and goodness itself."[70]

Two other artists who used the landscape to express idiosyncratic views of nature were Ralph Blakelock and Albert Pinkham Ryder. Both artists were highly regarded by their peers; both died isolated from the world: Blakelock in a hospital; Ryder at his apartment. Their works were extensively forged during their lifetime. The unconventional painting practices and the abstraction implied by the simplified forms they preferred—not to mention their seeming "outsider status" and uncertain mental state—made their work appealing to subsequent generations of Modernists. As was the case with Inness, their reputations never suffered the eclipse seen with so many of their other contemporaries.

Blakelock, the son of a physician, was expected to enter his father's profession but received erratic training in painting in New York before embarking, in 1869, on a long odyssey to what is now Colorado, the Dakotas, Utah, Wyoming, and California. He returned to New York via Mexico, Panama, and Jamaica. Financial hardship and the difficulty of supporting a large family may have contributed to Blakelock's fragile mental health, and from 1891 onward he was in and out of the hospital.

Recognized in his lifetime for his paintings of Indian encampments and moonlight landscapes, Blakelock also produced another category of landscapes focusing on the sky. Less picturesque than the Native American scenes and less obviously evocative than the moonlit scenes, the "open sky" landscapes have their own quiet intensity. They are, above all, paintings of light and air. *Landscape* (**fig. 46**), painted sometime in the 1880s, is exceptional even within this category in its cool restricted palette. The dark trees are silhouetted against the sky but also seem attached to it by Blakelock's trademark technique of painting dots of sky into the dark

45

46

47

foliage, a technique unsurprising today, but considerably ahead of the conventional practices of his day.

Ryder's technique was even more radical, involving painting and repainting the same composition on the same canvas over a time span as long as ten years. He sought to give his paintings the patina of the Old Masters, and his works are often dark and unstable, with a network of large and small cracks. Ryder himself claimed not to care about the deterioration of his art, citing the Venus de Milo as an example of beauty that defied the ravages of time. He likened his approach to art to that of an inchworm, "crawl[ing] up a leaf or twig, and then, clinging to the end, revolve in the air, feeling for something to reach something. That's like me. I am trying to find something out there beyond the place on which I have a footing."[71]

The Tempest (**fig. 47**), worked on between 1892 and 1911, must be regarded as a shadow of its former self; only X-rays can reveal why it was once described as being "one of the greatest of his canvases" and "as vivid as a Monticelli but more gemlike."[72] Other descriptions of the time emphasized the color and drama of the work, noting Ryder's special insight into Shakespeare. Toward the end of Ryder's life, visitors to the studio reported that the canvas was nearly black.

William Page was highly regarded by the cognoscenti of his day, his work applauded by John Ruskin as well as Elizabeth and Robert Browning, but he is almost invisible in today's art history books. In keeping with his perceived position as the successor to Washington Allston, Page sought to translate the grand tradition into a modern aesthetic, developing impressive, if arcane, theories that reflected his considerable learn-

48
William Page
Self-Portrait
1860–61
Oil on canvas
Gift of Mr. and Mrs.
George S. Page,
Blinn S. Page, Lowell
Briggs Page, and
Mrs. Leslie Stockton
Howell
37.60

49
William Page
Mrs. William Page
1860–61
Oil on canvas
Gift of Mr. and Mrs.
George S. Page,
Blinn S. Page, Lowell
Briggs Page, and
Mrs. Leslie Stockton
Howell
37.61

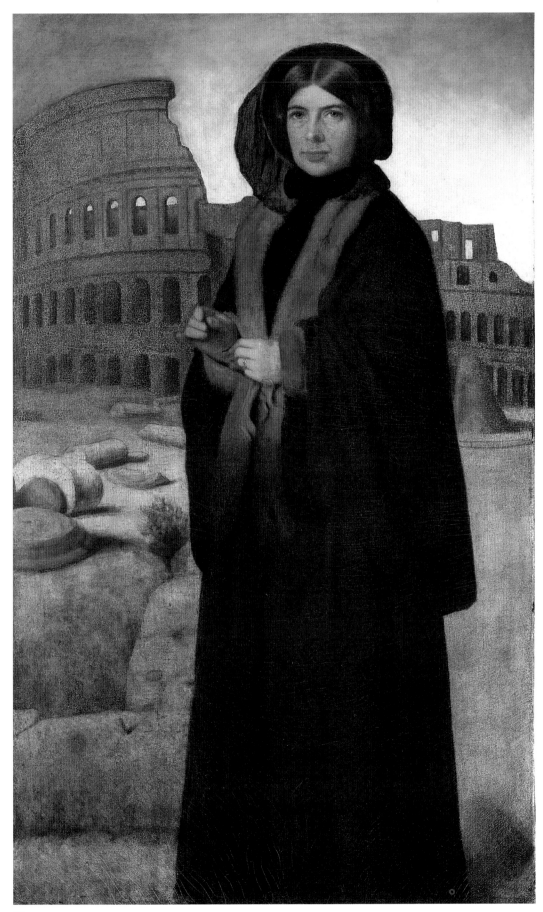

49

ing and no less considerable ego. In his own "private opinion" he had "done more for art than any man (or woman) since Titian."[73]

Unlike the earlier would-be Grand Manner artists, who had seen portraiture as a lesser, but lucrative, form of art, Page embraced it. "The order of nature is fixed in portraits as in planets" he asserted, and the pendant portraits of himself and his wife (**figs. 48** and **49**) are fully informed with his complicated theories.[74] Page sets himself in front of a reclining figure from the Parthenon, at the time thought to be that of Theseus, slayer of the Minotaur and symbol of the triumph of knowledge over ignorance. The artist—cut off at the feet, like the statue behind him—stands on a gridded floor suggesting an underlying universal order, which contrasts with the less structured network of lines created by the maulstick, watch chain, palette, brushes, spectacles, and cord, themselves the tools by which the artist brings order from chaos. The brush he holds in his right hand is tipped with bright red. Page believed that red was the foundation of skin tones, and here it works as a foil to the rest of the painting executed in the "middle tint" that, he believed, held the most color.

Page's elaborate theories of order were in stark contrast to his personal life. Until he married Sophia Candace Stevens Hitchcock, a young widow of considerable means, his private life had been extremely unsettled. His first wife had abandoned him and his three daughters; his second ran off with a Neapolitan nobleman after a spending spree that left Page penniless. With Sophia, however, he finally found stability and happiness. In her portrait, she is posed in front of a stripped-down version of the Coliseum, beside a somewhat indeterminate wall. She is in the process of adjusting her right-hand glove, a gesture that gives prominence to her wedding ring, an attribute of her position as wife and the counterpart to the tools of her husband's calling. In contrast to the dominant middle tones of Page's self-portrait, the painting of his wife is dominated by the black of her dress and the blue of the sky. Where he looks off into some unknown distance, her gaze engages the viewer. Oddly, hers is the more timeless portrait.

Elihu Vedder grew up in the United States and Cuba but, after study in Paris, spent most of his long life in Italy. In keeping with this background, Vedder drew on a wide range of sources for his idiosyncratic paintings, including William Blake's prints, Gothic stained-glass windows, Japanese woodcuts, and Renaissance sculpture. He was also interested in astrology as well as aspects of Eastern mysticism. His paintings, at times highly realistic, at others correspondingly mannered, polarized artistic opinion. "If it be the mission of an original talent to bring into the world, not peace, but a sword, Vedder has the compliment of creating this kind of turbulence," a critic wrote in 1880. "There began to be Vedderites and Anti-Vedderites very early in his career and moderation in the expression of their opinions has never been a marked trait of either."[75]

In 1886 Vedder embarked on three paintings dealing with the story of Samson and Delilah. The first, a small composition (now in the National Academy of Design), shows Delilah rising from the couch she shared with Sampson, scissors in hand and his shorn locks scattered around him. The other two are pendant "portraits" of *Samson* and *Delilah* (**figs. 50** and **51**), in which Vedder contrasts the fierce strength of the hero with the insidious charm of his seductress. Samson's head is posed erect; his hair—source of his supernatural power—flies out beyond the confines of the picture. A rope is coiled loosely about his neck, as if unable to contain his strength. Delilah, by contrast, is depicted peering sideways though parted curtains, her eyes beckoning Samson to his downfall. The frames, designed by Vedder, feature in relief various items associated with Samson's career: the lion he killed and the bees that made the honey which came from its carcass; the jawbone of an ass, with which he killed one thousand Philistines; the ropes that bound him; the scissors that sheared his locks; the coins Delilah was paid; the millstone he used to grind grain after his blinding; and the two cracked pillars he pulled down to destroy his enemies and himself.

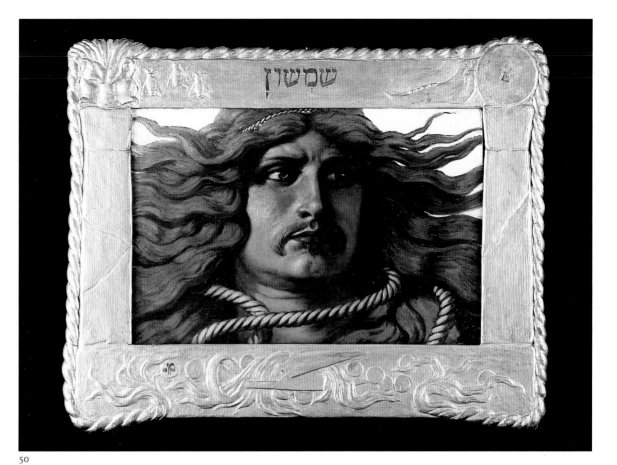

50
Elihu Vedder
Samson
1886
Oil on cradled wood
panel
Gift of Dr. and Mrs.
Joseph Chazan,
Arthur and Joyce
Hurvitz, and Irwin and
Gloria Sparr in honor of
Mr. and Mrs. Richard A.
Manoogian
1994.123

51
Elihu Vedder
Delilah
1886
Oil on cradled wood
panel
Gift of Dr. and Mrs.
Joseph Chazan, Arthur
and Joyce Hurvitz, and
Irwin and Gloria Sparr in
honor of Mr. and Mrs.
Richard A. Manoogian
1994.124

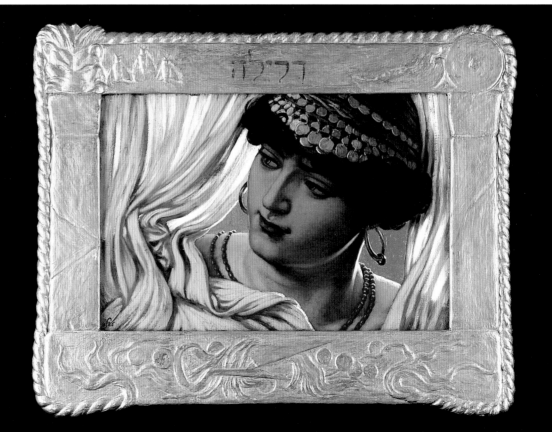

The development of sculpture essentially followed the course of painting: first hewing closely to European neoclassicism, then developing a more naturalistic approach, and finally incorporating such traits of late nineteenth-century artistic trends as aestheticism and realism.

By the middle of the nineteenth century, Hiram Powers was established, in contemporary minds, as America's greatest sculptor. Powers grew up near Cincinnati and had a studio in Washington before moving to Florence, where he embarked upon a series of idealized female busts. In 1842 he began work on *The Greek Slave,* the sculpture that would make his reputation. The original is a full-length nude, something that was unheard of in nineteenth-century American art. By the time a version of it was exhibited in America, Powers had made the sculpture palatable to American tastes by "dressing" it with a moral story. What audiences were looking at, the artist told them, was not a version of a dubious classical trollop, but a modern Christian woman captured in the Greek War of Independence. *The Greek Slave* was shown to acclaim across the country where it was hailed as a great artistic achievement. Today viewers are more likely to marvel at Powers's philosophical sleight of hand than any technical prowess. But his lesson of metaphorically covering nudes with a moral tale was quickly learned and imitated by other artists. Several full-length versions were made of *The Greek Slave*, as well as numerous busts. Detroit's version (**fig. 52**) is distinguished by the lace-like fringe that terminates the lower edge.

If Hiram Powers was as acclaimed for his introduction of the full-length nude into American art as for his actual sculpture, so Harriet Hosmer found her fame as a sculptor enhanced by her sex. Although one of several American women sculptors working in Rome, Hosmer's independent behavior made her legendary in her own time, and she was visited in her studio by the Prince of Wales and the Czar of Russia, as well as any number of lesser nobility. Born in Massachusetts, she trained in Boston but took anatomy

53

lessons in St. Louis, Missouri, since they were forbidden to her by law in her home state. She then went to Rome to study under the English sculptor John Gibson, the most prominent neoclassicist working there. Hosmer's work combined a neoclassical style with strong narrative or anecdotal content and was immediately popular. In *Medusa* (**fig. 53**), of 1854, the fearsome woman is depicted as if looking dreamily into the distance, and Hosmer's chosen style works to undermine the terror of her subject.

Henry Kirke Brown, born in Leyden, Massachusetts, was first trained as a painter. After brief stints in Boston and New York City, he joined the flourishing artistic community in Cincinnati in 1837 and took up modeling in clay. He returned to Boston for a year before establishing a successful portrait studio in Albany, New York, where he produced likenesses in both two and three dimensions. In 1842 he sailed to Europe. A visit to Rome opened his eyes to the riches of Europe's past, and he was soon working on sculptures based on classi-

cal mythology, biblical stories, and contemporary Italian street life. Returning to the United States, Brown, a staunch proponent of naturalism, achieved considerable success as a sculptor and trained members of the next generation of realistic sculptors. His *Filatrice* (**fig. 54**), although made several years after his 1846 return home, reflects his appreciation of classical antiquity in its idealized forms and pose. The subject of a woman spinning would have been easily understood by his contemporaries as a symbol of Fate.

Brown's mantle as the main proponent of American naturalism was inherited by one of his students, John Quincy Adams Ward. In an article in *Harper's Magazine* (June 1878) he attacked Rome for its "cursed atmosphere…which somehow kills every artist who goes there…it draws a sculptor's manhood from him…A modern man has modern themes to deal with; and…an American sculptor will serve himself and his age best by working at home." By the end of his long career, Ward's sculptures of generals, statesmen, and men of letters graced many streets and squares in America's major cities.

The Freedman (**fig. 55**), of 1863, was Ward's response to the recent emancipation of slaves. Ward poses his subject against the stump of a tree, one remnant of the former slave's shackles on his left wrist, another piece held in his right hand. He looks into the distance and seems about to rise to his feet, as if commencing on a new journey. A slight classical tinge is given to the work by the loincloth, which covers the ex-slave, a curious touch by such an avowed realist as Ward, but one that would probably have signaled nobility to his audience.

Alexander Milne Calder trained in Scotland and Paris before moving to Philadelphia in 1868. His experience in Paris, where he saw the newly completed additions to the Louvre, made him well suited to carry out the elaborate sculptural decorations for Philadelphia's City Hall. This was a task that consumed his energies for much of his career. Calder seems to have been allowed considerable leeway in developing the building's complicated iconographical program and adapted his style to the subject at hand: classical for

54

54
Henry Kirke Brown
Filatrice
1850
Bronze
Founders Society
Purchase, Eleanor and
Edsel Ford Exhibition
and Acquisition Fund
1989.76

55
John Quincy Adams
Ward
The Freedman
1863
Bronze
Gift of Mr. Ernest
Kanzler
45.5

56
Alexander Milne Calder
William Penn
1886
Bronze
Founders Society
Purchase, Laura H.
Murphy Fund
42.106

55

the symbolic figures, realistic for American subjects.
Crowning everything was a statue of William Penn, over
eleven meters (thirty-six feet) high. Seen here (**fig. 56**) in a
diminutive bronze version, the founder of the state of
Pennsylvania offers a blessing with his right hand, while
holding his famous treaty with the Native Americans in his
left. The restrained pose, in keeping with Penn's Quaker
temperament, was also dictated by the sculpture's great size.[76]

From Contretemps to Entente Cordiale

James McNeill Whistler, detail of *Arrangement in Gray: Portrait of the Painter,* ca. 1872 (fig. 57)

The Revolutionary War may have severed political ties between Britain and the United States but, as has been seen, cultural and artistic bonds remained very strong. Up until the 1860s, aspiring American artists favored London as a base for European travels, and their work clearly reflected British sources; from Sir Joshua Reynolds's theories on hierarchies in art and Edmund Burke's sense of the sublime to John Ruskin's writings on art and nature.

In the 1850s, the painters of the Hudson River School were clearly in the ascendancy, their landscapes hailed as quintessentially American and their products recognized as the best branch of painting. "Landscape painting," wrote one journalist, "has acquired in our country a dignity and character…which cannot be claimed for any other branch of the fine arts…Here we may gain a proud eminence among the nations, and here alone…future artists [will] build up a distinctive school…whose fame is to be co-extensive with that of our industry."[77] In the 1860s, however, critical scrutiny, both at home and abroad, of the aesthetic and philosophical underpinnings of art resulted in a shift among painters away from English influences to those of France. The 1867 Exposition Universelle in Paris marked the turning point in thinking about American art. The preponderance of works selected to represent the nation at the exposition were landscapes, reflecting the dominance of the Hudson River School. The resulting exhibition was a disaster, deplored equally by critics from both sides of the Atlantic. In French eyes, American artists were deemed inferior followers of the English school; an American critic wrote that Bierstadt's work looked "cold and untruthful…a tableau like inventory." Church's painting *Niagara,* which had won great acclaim in London, was "a cold hard atmosphere and metallic flow of water…a literal transcription of the scene." The same writer concluded that such work "taught us a salutary lesson in placing the average American sculpture and painting in direct comparison with the European, thereby proving our mediocrity."[78] To make matters worse, the Salon of 1867 saw

the triumph of genre over other forms of paintings. According to one exhibition review, this category once "so disparaged, so cursed, so persecuted…ascend[ed] to the heights of history painting attacking the idea of universality of nature and of life, becoming finally the entire painting of the present as, I hope, it will be of the future."[79] American landscape paintings, with their sparsely inhabited vistas, could hardly have been more out of step with trends in the all-important art circles of Paris.

This very public humiliation came at a time when Americans at home were, themselves, beginning to question the precepts of the Hudson River painters. Even before the disaster in Paris, a writer reviewing the National Academy's 1867 exhibition wrote waspishly, "So far as the enjoyment and instruction of the public are concerned, the Academy might cover its walls year after year with the same pictures."[80] The public, satiated by a diet of spectacular effects, now found their repetition dull. The nation's new wealth enabled increased travel for its citizens and artists and brought foreign works of art flowing into the country, factors that resulted in increasingly cosmopolitan tastes in general, and an appreciation for French art in particular. American artists had always traveled to Europe but had often done so in trepidation of losing some of their Americanness. After 1867 they went abroad with a determination to learn from the best and to recreate the very nature of American art. London and Düsseldorf remained important sources of influence, but Paris became the new center of gravity.

The extent to which James McNeill Whistler can be considered an American artist is debatable.[81] Although his manners and behavior left the English no doubts as to his country of origin, he never painted a mature picture in the United States. His art and theories derive entirely from his experience in Paris and London. After working for a time for the Coastal and Geodetic Survey in Washington, D.C., where he gained valuable training in the etching technique, he went to Paris in 1856 to study in the atelier of Charles Gleyre. Through Courbet and Fantin-Latour, he was exposed to the

57

new ideas circulating outside the academic realm. He moved
to London in 1863, where he quickly established himself at the
center of forward-thinking artists and began to develop his
own style: a combination of Japanese and Grecian motifs with
a loosely brushed mode of painting. He completely rejected
the narrative aspects of painting and emphasized the impor-
tance of intrinsic formal and symbolic qualities by using
musical terminology in his titles. His attitudes put him at the
center of the burgeoning Aesthetic movement; his wit and
writings often put him at the center of controversy, something

58

57
James McNeill Whistler
Arrangement in Gray: Portrait of the Painter
Ca. 1872
Oil on canvas
Bequest of Henry Glover Stevens in memory of Ellen P. Stevens and Mary M. Stevens
34.27

58
James McNeill Whistler
Nocturne in Black and Gold: The Falling Rocket
Ca. 1874
Oil on oak panel
Gift of Dexter M. Ferry, Jr.
46.309

he relished. The only person he seems to have feared was Edgar Degas who, observing Whistler's antics on one occasion, rebuked the American for behaving as if he had no talent.[82]

Painted soon after his famous portrait of his mother (titled by the artist *Arrangement in Gray and Black*), Whistler's self-portrait *Arrangement in Gray: Portrait of the Painter* (**fig. 57**) offers little or no psychological insight into the sitter, although it certainly makes his ambition clear. The most obvious reference is to Rembrandt's *Self-Portrait* of 1640, in the National Gallery, London, where the artist presents himself half-length, somewhat sideways to the viewer, and wearing an ample black beret. The other presence is that of Velázquez, whose subdued color harmonies and empty backgrounds inspired Edouard Manet as well as Whistler. The influence of Japanese woodcuts can be seen in the dado—the line that divides the two-colored background—on which Whistler's "butterfly" signature rests. Whistler also incorporated the symbol into the frame, which he designed.

Nocturne in Black and Gold: The Falling Rocket (**fig. 58**), of about 1874, was the subject of one of the most famous court cases in the history of art. In this work, Whistler's ideas on the supreme importance of form and design over legible content are given full expression. Using a firework display over the Cremorne Gardens in Chelsea as the ostensible subject, Whistler created a work verging on the abstract. Pink and gold spatters of paint recreate the falling rocket as its sparks tumble back to earth against a blue-black background of loosely defined foliage and sky. He is interested not in describing a particular event but evoking the sensation of fugitive pyrotechnics in a darkened landscape. John Ruskin, the most powerful voice in the English-speaking art world since the 1840s, was not impressed. "I have seen, and heard, much of cockney impudence before now; but I never expected to hear a coxcomb ask two hundred guineas [£220] for flinging a pot of paint in the public's face."[83] Perhaps privately stung by the mockery of his aristocratic-dandyish pretensions through Ruskin's use of the words "cockney" and "coxcomb," but

certainly outraged at the attack on his craft and on his prices, Whistler sued for libel. The resulting trial brought a parade of famous artists to testify on both sides and the reports of the proceedings—as well as Whistler's own recounting of it a number of years later in *The Gentle Art of Making Enemies*—throw a wonderful light on the attitudes and personalities of the time. Whistler was in his element and used the witness box as a pulpit to proclaim his ideas. "I have perhaps meant [*Nocturne*] to indicate an artistic interest alone in the work…It is an arrangement of line, form, and color first and I make use of any incident which shall bring about a symmetrical result."[84]

Whistler won the case but the jury, reflecting a widespread feeling that, entertaining though it had been, the case was frivolous, awarded Whistler one farthing in damages and instructed each side to pay their own costs. Ruskin's friends rallied round to help him, but no one rushed to Whistler's aid. He was bankrupted and forced into exile while he worked his way back to solvency. For Ruskin, the affair marked the end of his near hegemony in criticism. Whistler re-established himself in England in the 1880s, where he was admired by a growing number of younger artists. He moved to Paris in 1892 and traveled back and forth between that city and London until his death in 1903.

Mary Cassatt is another American artist whose work fits more easily into the context of European painting than that of the land of her birth. Her greatest contribution to the visual arts in America may well be through her influence, which she exercised on wealthy patrons to buy the French Impressionist works that now hang in a number of great East Coast art museums. Born near Pittsburgh, she spent from 1850 to 1860 in Europe, returning to America to study at the Pennsylvania Academy until late 1865, after which she returned to Paris. Over the next few years, interspersed with travel to Italy, she studied in several ateliers, including those of Jean-Léon Gérôme and Thomas Couture. Driven back to Philadelphia by the Franco-Prussian War of 1870–71, she returned to Europe in 1872, and after a final visit to Philadelphia in 1875,

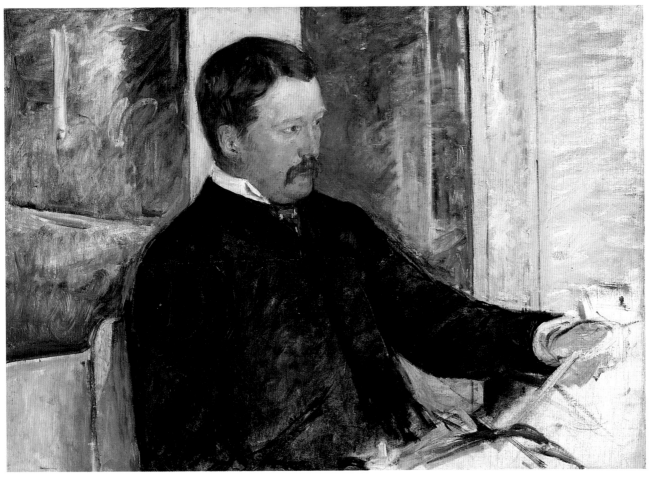

59

settled in Paris. Apart from a visit to the East Coast in 1898, when she executed a considerable number of portrait commissions, she lived in France for the rest of her life.[85]

All who met Cassatt testified to her strength of character and acuity of mind, and not the least of her achievements was to retain the life-long friendship of the difficult Edgar Degas. "No woman," she later recorded him as saying, "has the right to draw like that."[86] Of Degas's work she said, "The first sight of [his] pictures was the turning point in my artistic life."[87] Cassatt had successfully submitted works to the official Salon for a number of years, but when invited by Degas in 1877 to exhibit at the next (fourth) "Impressionist" exhibition, she abandoned the Salon as a venue and aligned herself with the unofficial wing of French art. Except for the seventh exhibition, when she supported Degas's boycott, she exhibited at all subsequent ones.

Being independently wealthy, Cassatt had little need to paint portraits for fees and many of her works in this area are

of family and friends. *Alexander J. Cassatt* (**fig. 59**) is an unusual choice of subject for her—a male sitter. Mary Cassatt's elder brother, Alexander, was first vice president of the Pennsylvania Railroad, and when she painted him in 1880 at the family's house in Marly-le-Roi, he was, at age forty-one, wealthy, socially prominent, and at the pinnacle of his career. Even though the picture is unfinished in most areas, the head is fully worked. Cassatt depicts her successful brother in a contemplative moment; a private, informal view of an otherwise energetic, public man.

Born in Florence to American parents, John Singer Sargent spent his youth moving around Europe. He grew up speaking four languages, played the piano expertly, and showed his artistic talent early. Unlike Cassatt, Sargent did not have a moneyed background. His parents' peripatetic lives were essentially driven by the restless energy of his mother, who persuaded his father to exchange a promising career in medicine in Philadelphia for the vagaries of an intellectual, if not

59
Mary Cassatt
Alexander J. Cassatt
Ca. 1880
Oil on canvas
Founders Society
Purchase, Robert H.
Tannahill Foundation
Fund
1986.60

60
John Singer Sargent
Madame Paul Poirson
Ca. 1885
Oil on canvas
Founders Society
Purchase with funds
from Mr. and Mrs.
Richard A. Manoogian,
the Beatrice Rogers Fund,
Gibbs-Williams Fund,
and Ralph Harman
Booth Bequest Fund
73.41

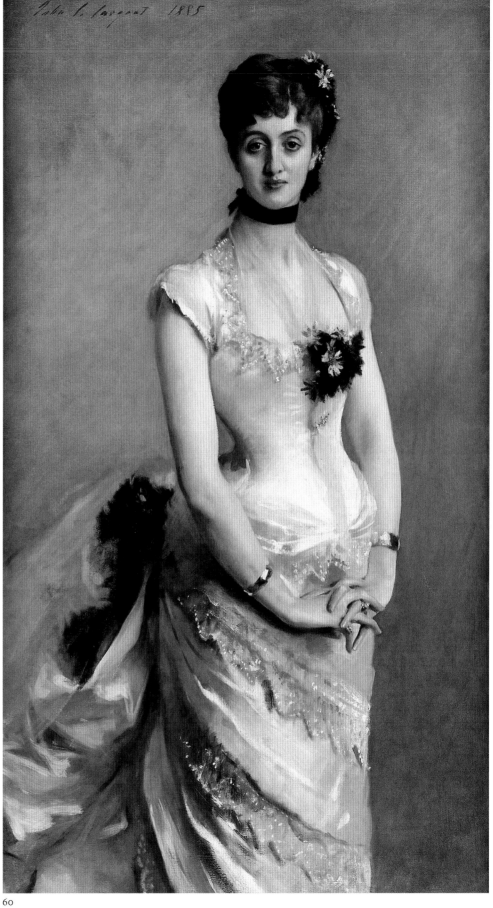

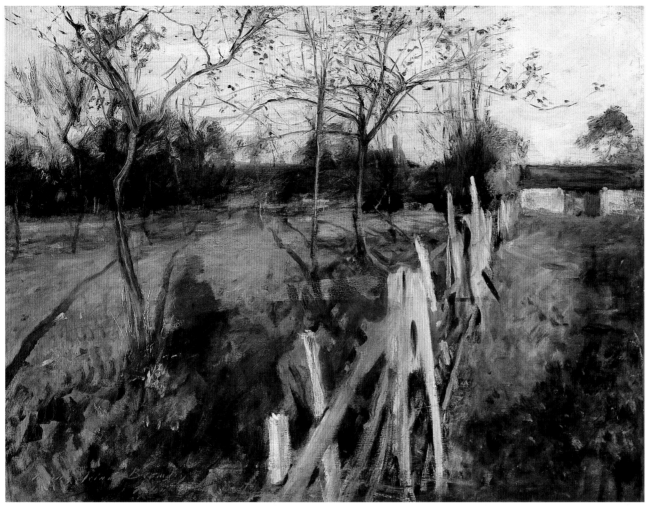

61

61
John Singer Sargent
Home Fields
1885
Oil on canvas
City of Detroit Purchase
21.72

62
John Singer Sargent
Mosquito Nets
1908
Oil on canvas
Founders Society Purchase,
Robert H. Tannahill
Foundation Fund, and
Founders Society Acquisition
Funds, and by exchange
1993.18

quite bohemian, life in Europe. A distant relative succinctly summed up his life:

> Sargent was European in his taste and upbringing, American in his habits of thought and moral code. A true cosmopolitan, he never seems to have suffered a crisis of identity, remaining staunchly self-reliant through all the changes and uncertainties of his early life. Though he did not visit his native country until he was twenty-one, he was proud of his American ancestry and sensible of the advantages it might bring him.[88]

In 1874 he enrolled in the studio of Carolus-Duran and soon achieved primacy among the students there. Sargent's portrait of Duran, exhibited at the Salon in 1879, was widely regarded as being as much a challenge as an *homage*. Any ambitions he may have had in Paris, however, were blighted by his controversial *Portrait of Madame X*, exhibited at the 1884 Salon. Shocked by the vehemence of the criticism (the sitter belatedly joined in), Sargent moved to London, where his reputation was already emerging. He traveled incessantly around Europe for the rest of his life; the twin poles of his career, after he left Paris, were London and Boston.

The portrait of *Madame Paul Poirson* (**fig. 60**) was painted in 1885, the year after Sargent's disastrous exhibition of *Madame X*. It indicates clearly the path he was to take over the next two decades, which would make him the preferred purveyor of portraits to the upper classes of Britain and America. The subject is shown, three-quarter length, posed against a plain, loosely brushed background, the soft green-blue hues of which complement the sheen of her dress. Beautiful yet demure, Madame Poirson stands slightly sideways but turns her face to the viewer, a pose that allows Sargent to emphasize her large dark eyes as well as to downplay what seems to be a rather prominent nose. If the composition recalls that of Frans Hals or Velázquez, the handling and color

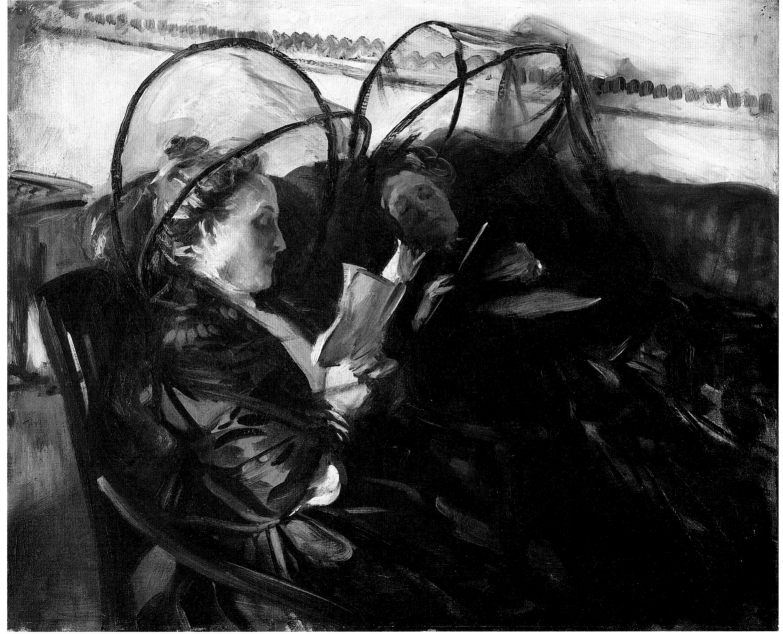

63

owes a greater debt to Van Dyck, whom Sargent was to emulate in his society portraits over the coming years. Surrounded by opulent furnishings and architecture, his wealthy sitters are generally dressed in striking costume and, as with Madame Poirson, depicted without any attempt at psychology or symbolism—beyond, of course, their obvious wealth.

At the beginning of his second year in England, Sargent joined an Anglo-American artists' colony in Broadway, Worcestershire. Here he amazed all and sundry by his habit of marching into a field with his artist's paraphernalia where, apparently without forethought, he set himself up and started to paint. The spontaneity of this approach is well illustrated in *Home Fields* (**fig. 61**), where the raking asymmetry of the brightly lit fence and terminal barn makes a dynamic contrast to the greens and purplish-browns of the landscape. His works at Broadway, though focused on landscape, eschewed the modern-life agricultural subjects common to the work of other members of the colony. Figures, when they appear, are middle class and leisured, and it is indicative that the major "studio" piece that Sargent produced in Broadway at this time was *Carnation, Lily, Lily, Rose*, a fairyland-like double portrait of his host's two little daughters.

Mosquito Nets (**fig. 62**), 1908, depicts the artist's sister Emily on the left and Eliza Wedgewood, her traveling companion and member of the Wedgewood Pottery family, on the right.

It was painted in Majorca and depicts the two women reading, under the devices Emily invented to keep away the mosquitoes. Sargent, according to Emily, called them "garde mangers." As with *Home Fields*, the composition of *Mosquito Nets* is a sophisticated balance of the seemingly spontaneous and the carefully structured. The furnishings and architecture set up a grid of diagonals within which the softer forms of the figures repose. The fluid treatment of the black costumes recalls the brushwork of Hals and Velázquez; the looping forms of homemade protective devices become a witty reprise on the elaborate headdresses of earlier Spanish noblewomen.

Among the founding artists of the Broadway Group was Francis Davis Millet, whose travel patterns were the reverse of Sargent's. Trained as an artist in Antwerp, Millet traveled and exhibited extensively in Europe, but was based in Boston. From there he balanced his career as a painter with that of a journalist (in 1898 he covered the Spanish-American War from Cuba and the Philippines) and arts administrator. He was a trustee of the Metropolitan Museum of Art, founding secretary of the American Federation of Arts, and a charter member of the American Academy in Rome. In 1911 he accepted the directorship of the Academy, and it was in the course of carrying out his duties in this capacity that he found himself on the *Titanic* in 1912.

By 1885 Millet was spending half a year in Broadway, and

65
Gari Melchers
The Communicant
Ca. 1900
Oil on canvas
Bequest of Mr. and Mrs.
Charles M. Swift
69.527

his work clearly reflected the influence of the painstaking classicizers Albert Moore and Lawrence Alma-Tadema. Moore, a leading painter in the Aesthetic movement, evolved a subject matter of young women in diaphanous Greco-Roman costume, lying or standing around in frieze-like arrangements, either sleeping or doing very little. Compared to Moore's catatonic women, those of Millet's *Reading the Story of Oenone* (**fig. 63**) are positively alert. The title indicates that the women are absorbed in the tragic story of Oenone, the wife of Paris, who was abandoned for Helen of Troy. When, later, Paris asked forgiveness and, at the same time, that Oenone dress his wounds suffered in the Trojan War, she refused. By the time she relented, Paris had died. Grief-stricken, Oenone committed suicide. The women portrayed in the painting wear four markedly differentiated costumes. Shortly before he commenced *Reading the Story of Oenone*, Millet delivered a series of lectures on Roman costume at the Museum of Fine Arts, Boston, as well as at two venues in New York. In these talks he emphasized the details and function of particular garments. He appears to have incorporated his specialized knowledge into this painting.

As with Benjamin West and James Whistler, it is debatable to what extent the paintings of Julius Stewart can be considered American. The son of a wealthy Philadelphia businessman, Stewart was only ten when his father moved permanently to Paris. By the age of sixteen he was studying with the Spanish painter Eduardo Zamacoïs and, following the latter's unexpected death, enrolled first with Gérôme and then Raimundo de Madrazo. Under their influence his earliest work was characterized by brightly colored canvases depicting beautiful and beautifully dressed young women in moments of repose. Influenced by James (Jacques) Joseph Tissot's detailed paintings of comfortable, everyday life, he subsequently developed the format of large-scale horizontal paintings, depicting events of significance for the leisured classes to which he belonged. For all of these influences and his secure position in the Paris art world, Stewart was firmly

part of the American expatriate community and regularly sent his paintings to the States for exhibition. They were given a mixed reception: the general public liking them and collectors acquiring them, critics fretting over them, simultaneously admiring the technique while deploring the "frivolous" subject matter.[89] By the time Stewart painted *Wood Nymphs* (**fig. 64**), the artistic climate in Paris had changed considerably. The various forms of Realism that had struggled for primacy were giving way to Symbolism and a search for underlying "truths." This painting can be seen as Stewart's partial response to the change. Three women, two of them naked, loll about in a forest clearing vaguely communicating with one another. The soft, pink tones of their bodies stand out in near-silhouette against the greens and browns of their surroundings. But, as was noted at the time, any sense of languorous idyll is undermined by the particular realism of the nudes: "His nymphs," wrote one critic, "are none other than the pretty Parisian girls he knew so well how to dress, and…he undresses them today with the same talent."[90]

Born in Detroit to a Westphalian sculptor, Julius Garibaldi "Gari" Melchers studied with his father before enrolling in the Düsseldorf Royal Art Academy in 1877. Four years later he moved to Paris, where he studied at the Académie Julian and exhibited at the Salon of 1882. In 1889, along with his fellow expatriate, John Singer Sargent, he won a Grand Prix at the Paris Exposition Universelle. By this time Melchers had established his studio at Egmond-aan-Zee and, although he traveled regularly, considered the Netherlands to be his home. He established his reputation as a painter of Dutch genre scenes, many of them having religious overtones, such as *The Communicant* (**fig. 65**), in which a girl is posed in her Sunday best. Book open, staring directly at the viewer, the communicant's piety is subtly undermined by her "pigeon-toe" feet and off-center placement on the chair. Melcher's painting is simultaneously a portrait of an awkward child and a statement of enduring community values.

Interlude: Thomas Eakins

Now recognized as one of the United States' most distinctive painters, for much of his career Thomas Eakins was dogged by controversies relating directly to his choice of subject matter and his teaching methods. Eakins was born in Philadelphia and first trained at the Pennsylvania Academy of the Fine Arts from 1862 to 1866. He then spent four years in Paris, where he studied in the atelier of Jean-Léon Gérôme. Although their finished works are very different, the training Eakins received under this arch academician was to exercise a lasting influence, especially in the matter of life study drawings. Eakins's work can be viewed as the application of French academic methods to everyday American themes. His startlingly realistic depiction of an anatomy lesson, *The Gross Clinic*, 1875, was considered too gruesome to hang in the art pavilion of Philadelphia's Centennial Exposition and instead was shown with the medical exhibits itself. As a professor at the Pennsylvania Academy from 1876 on, he was able to transform the curriculum, gathering about him a large circle of dedicated students. He became fascinated with photography, using it to explore the human figure in motion. Convinced since his time with Gérôme of the primacy of life figure drawing, he insisted on including male models in the Academy's women's classes as well as the men's. After mounting protests from outraged parents and clergy, Eakins was dismissed from his post as director of the Academy in 1886.

Painted in the year of his dismissal, Eakin's *Dr. Horatio C. Wood* (**fig. 66**) depicts a professor of nervous diseases. The portrait is a sympathetic one, showing a well-groomed professional man at work in a comfortable interior, his black clothes set off by the warm red and brown tones of the furniture, carpet, and drapery. But it is this very air of solidity that differentiates Wood's portrait from Eakins's best work in this genre, which is usually characterized by strong lighting effects and stark tonal juxtapositions. Ironically, many years later, this straightforward image was the center of a dispute between Wood and the artist's widow. In 1917, on being asked to provide a portrait of himself for the College of Physicians

of Philadelphia, Wood recalled the Eakins picture of 1886, for which he had paid $150 but never received. Not convinced of his ownership, Susan Eakins suggested that Wood secure the portrait by exchanging it for two other paintings by Eakins, which Wood had acquired prior to sitting for his portrait. In an attempt to outline the events that had led to Mrs. Eakins still possessing the painting, Wood related how, on his first taking the portrait home:

> It was received with so much disfavor that Mr. Eakins, hearing the criticism, asked me to bring it back to him…I suppose I got tired of sitting…and I was so busy myself that finally I forgot all about it…Your husband was never strong in portraiture though he did wonderful work in picture-making, and I want to say that the two pictures which I own I consider gems.[91]

As Eakins had frequently made portraits of individuals he found interesting without charging a fee, it is hardly surprising that the recently widowed Mrs. Eakins was unmoved by Wood's tactless arguments. The portrait remained in her possession until 1930, when it was purchased from her by the Detroit Institute of Arts.

66
Thomas Eakins
Dr. Horatio C. Wood
1886
Oil on canvas
City of Detroit Purchase
30.296

Impressionism and Realism

In 1877 another American student of Jean-Léon Gérôme wrote to his parents back home. "I went across the river and saw a new school which call themselves the Impressionalists [*sic*]. I never in my life saw more horrible things…Worse than the chamber of horrors…I stayed fifteen minutes."[92] It was J. Alden Weir's first encounter with a movement that he would soon come to champion in America and which would dominate the country's art scene for the last two decades of the nineteenth century. By the late 1870s, American artists were flooding to Paris and had established a colony in Pont Aven, Brittany. As was the case with Weir, many of them were trained in the ateliers of the French academicians, and many exhibited successfully in the official French venues. They worked in different styles, reflecting various masters— Bastien-Lepage, Carolus-Duran, Gérôme—but there was general agreement that American art was now nearly indistinguishable from French art. "Their talent does us too much honor," noted one critic, "that we should complain about it. In the American gallery one would imagine himself in a French gallery."[93]

This development had been matched in collecting habits in the United States. In 1877, commenting on the explosion of mansion building and the need for art to fill them, the editor of the *North American Review* made the point that "Painters were urged to turn out bad imitations and superficial reproductions of foreign and especially French schools. Purchasers longed to see their walls hung with subjects that would recall to the Regnaults, the Meissoniers, and Geromes, of Transatlantic fame."[94] And, just as after 1880 American artists were inexorably drawn to Impressionism, so American collectors followed. Mary Cassatt began advising family members and friends to collect the work of Degas and his fellow travelers. By 1886, when the Impressionists' main dealer Paul Durand-Ruel opened his first exhibition in New York, Claude Monet was already lamenting that "You only have eyes for America…you're being forgotten here: as soon as you have new paintings they're gone."[95] Most significantly,

highly talented American artists were returning home to paint, in the new, exciting manner, the American scene.

A crucial figure in the training of several American Impressionists was Frank Duveneck, who studied not in Paris, but in Munich. At the Royal Academy of Fine Arts from 1869 to 1873, he received instruction from the brilliant Wilhelm von Dietz, mastering a bravura painting style based on Hals, Velázquez, and Rubens. Duveneck returned to the United States in 1873, where an 1875 exhibition in Boston attracted favorable attention from the novelist Henry James, among others. Duveneck went back to Munich that same year, and thirteen students left the National Academy of Design to study with him. At times his students numbered as many as sixty and included William Merritt Chase and John Twachtman. In 1880, he established his own school, first in Florence and then in Venice, and his students—now known as the "Duveneck Boys"—followed him. In 1886 he married, but, following his wife's sudden death two years later, retreated to self-imposed exile at his family home outside Cincinnati. He remained highly regarded and occasionally taught in Chicago and New York. In the 1915 Panama Pacific International Exhibition in San Francisco an entire room was dedicated to his paintings.

Seated Nude (**fig. 67**), dating from Duveneck's second Munich period, is typical of his work in its riotous application of paint and stark contrast of light and dark. Despite the breadth of his brushstroke, Duveneck captures the subtle nuances of the brightly lit body and head, and this tension between loose brushwork and accurate delineation is the hallmark of his best paintings. It is little wonder that both Whistler and Sargent admired his work and counted him as a potential rival.

One of the "Duveneck Boys," William Merritt Chase had studied at the National Academy of Design from 1869 to 1871 and the Royal Academy, Munich, from 1872 to 1878. He returned to New York, where he quickly established himself as a major influence through his multiple roles as painter,

teacher, and tastemaker. His studio, which he called "the Atelier," was lavishly decorated, and Chase emulated Whistler's aristocratic manner. He was a leader in founding progressive art organizations such as the Society of American Artists and, after 1902, regularly exhibited in the annual exhibition of "The Ten," a group of American Impressionist painters founded by J. Alden Weir, among others. At the end of his life Chase grandly asserted, "I happen to be a member of the most magnificent profession that the world knows…It has a standard established for all time of the highest dignity."[96] On the other hand, his extravagant style of living nearly drove him to a Whistler-like bankruptcy, and when the sale of his studio contents at an auction in 1896 proved disappointing, Chase threatened to live abroad. Chase was a leading practitioner among American artists of *plein air* painting and his landscapes have all the vivacity and color expected of the Impressionist style. Though capable of brilliant coloristic essays in portraiture for this genre, he tended to favor the muted palette seen in the *Portrait of a Lady in Black* (**fig. 68**), where references to Velázquez and Van Dyck predominate. Chase was arguably the most influential teacher of his day, and his students included artists as different as Rockwell Kent and Georgia O'Keeffe. His Summer School of Art at Shinnecock at the eastern end of Long Island attracted both serious students and wealthy amateurs, a blend of money, high society, and successful artists that continues to characterize that part of the world even today.

After study in Chicago and New York, Theodore Robinson went to Paris in 1876, where he continued his training for three years under Carolus-Duran and Gérôme. Traveling between New York and Paris he absorbed the influence of, first, the Barbizon school and, ultimately, Claude Monet, whom he met in 1888 in Giverny. For the remainder of his short life (he succumbed to a life-long affliction of asthma), he was an important conduit for the influence of Impressionism in America. Like Monet, Robinson often worked in a series format, and his 1890 painting *Scene at Giverny* is one

67
Frank Duveneck
Seated Nude
Ca. 1879
Oil on canvas
Founders Society
Purchase, Robert H.
Tannahill Foundation
Fund
1992.41

68
William Merritt Chase
Portrait of a Lady in Black
Ca. 1895
Oil on canvas
Gift of Henry Munroe
Campbell
43.486

69

of several depicting the "haystacks" that Monet had made famous. Unlike Monet, however, Robinson uses a nearly panoramic composition and the flattened forms of the buildings have a solidity alien to Monet's shimmering forms (**fig. 69**).

Visiting Giverny with Robinson in 1887 was Willard Metcalf, who went there each year between 1885 and 1888 and, even though he did not personally adopt a full-blown Impressionist style until several years later, was instrumental in establishing the artists' colony there. Metcalf had financed his studies in Paris with the proceeds of a modestly successful career as an illustrator, but returning to Boston in 1890 he won immediate acclaim with a solo exhibition, which gave

Americans a modified glimpse of Impressionism. He moved to New York in the same year, where he supported himself by teaching and producing magazine illustrations. He was a founding member of The Ten and, after 1895, devoted his career to painting the New England landscape. He regularly withdrew to country retreats favored by artists, such as Gloucester, Massachusetts (1895), Walpole, Maine (1903–4), and Old Lyme, Connecticut (1903–7). *The White Veil* (**fig. 70**) was painted during a sojourn in Cornish, New Hampshire, and is typical of much of Metcalf's work in adopting a high vantage point. In its restrained color and careful composition—a series of overlapping light and dark triangles against which a vertical filigree of branches are set— *The White Veil*

70

exemplifies the strong decorative emphasis that separates American Impressionism from its French parent.

Childe Hassam, who took credit for Metcalf finally adopting an Impressionist technique, came from a wealthy Boston merchant background. He had also worked as an illustrator, trained as a painter, and established a studio in his hometown before traveling to study in Paris. Returning to America, he settled in New York where he painted its parks and public squares in a manner reminiscent of Monet and Pissarro, in the conviction that "the thoroughfares of the great French metropolis are not one whit more interesting than the streets of New York. There are days here when the sky and atmosphere are exactly those of Paris, and when the squares and parks are every bit as beautiful in color and grouping."[97] For *Place Centrale and Fort Cabanas, Havana* (**fig. 71**), Hassam employs the high vantage point and light palette that he favored for his New York park scenes. But, whereas, in his New York scenes, Hassam tended to present a large open space backed by tall buildings, in *Place Centrale Havana* he crowds the foreground with heavily foliated trees and lays out the architecture as a series of horizontal bands that progress up to the distant hills. In so doing, Hassam carefully balances the deep recession of the view with a compositional device that asserts the importance of the picture plane.

In his early years, John Twachtman, also a founding member of The Ten, was closely associated with Frank Duveneck.

71

71
Childe Hassam
*Place Centrale and Fort
Cabanas, Havana*
1895
Oil on canvas
City of Detroit Purchase
11.5

72
John Twachtman
The Pool
Ca. 1890–1900
Oil on canvas
Gift of Charles L. Freer
08.7

72

Twachtman studied under Duveneck in Cincinnati and, when Duveneck returned to Munich, Twachtman went with him. After working in New York for two years, he returned to Europe in 1882, studying at the Académie Julian from 1883 to 1885 and coming into contact with many future American Impressionists. Returning to America he acquired property in Greenwich, Connecticut, and, like Hassam and Metcalf, began to apply the lessons he had learned in France to the landscape of his native land. As can be seen in *The Pool* (**fig. 72**), he was a bold experimenter, mixing pigments directly on the canvas and juxtaposing rough paint surfaces with areas

hardly touched at all. His early death deprived the American Impressionists of an original voice, which was barely recognized outside artistic circles. Thomas Dewing declared Twachtman to be "the most modern spirit, too modern, probably, to be fully recognized or appreciated in his own day."[98]

Born in Salem, Massachusetts, Frank Benson was another wealthy Yankee who trained in Paris (at the Académie Julian) after studying in Boston. He briefly taught at the Portland School of Art in Maine before returning to Salem, commuting to teach and paint in Boston. He was also a founding

73

member of The Ten, and his adoption of an Impressionist style singles him out from his Boston colleagues at the School of the Museum of Fine Arts, where he worked. He preferred compositions featuring small groups or single figures, often his wife and children, posed in brightly lit landscapes or elegant interiors. *My Daughter Elisabeth* (**fig. 73**) exemplifies the demure subject matter that brought Benson so much success in his lifetime.

Equally demure, but very different in mood and execution, were the paintings of William MacGregor Paxton. In his compositions, women are shown engaged in quiet activities such as reading or sewing. In the 1913 painting *Woman Sewing* (**fig. 74**), the subject is shown absorbed in her work and bathed in a bright light, which streams in through a window behind her. The overwhelming single influence is that of the

seventeenth-century Dutchman Jan Vermeer—a painter of light, but not an artist usually admired by those associated with Impressionism. The texture and hues of the woman's dress in Paxton's work recall the tapestries and rugs of the Dutch painter's interiors and, just like Vermeer, Paxton overlaps his furniture so that the viewer's eye is led easily from foreground to background. A picture within the picture appears to show another of Paxton's paintings of a young woman seated in an interior. Only the hat cast upon the chair against the back wall hints at an outside world. Conservative to modern eyes, the works of Paxton and his associates in Boston seemed to offer an exciting alternative to the seemingly endless variants of Impressionism, which dominated western painting at the time.

73
Frank Weston Benson
My Daughter Elisabeth
Ca. 1914
Oil on canvas
Detroit Museum of Art
Purchase, Special
Membership and
Donations Fund with
contributions from
Philip, David, and Paul R.
Gray, and their sister
Mrs. William R. Kales
16.31

74
William Paxton
Woman Sewing
Ca. 1913
Oil on canvas
Founders Society
Purchase, Merrill Fund
21.70

74

Beautiful Ladies and the Aesthetic Movement

Thomas Wilmer Dewing practiced as a portrait painter in Albany, New York, before studying in Paris from 1876 to 1878. In 1880 he settled in New York City, marrying Maria Richards Oakey, a flower painter and writer on interior decoration whose needlework designs had been admired by Oscar Wilde. Dewing's earlier work combined the influences of Whistler and Pre-Raphaelite painter Edward Burne-Jones, but after visits to the artists' colony at Cornish, New Hampshire, his preferred subject became graceful and ghostly young women, floating through saturated green landscapes. Or, as one observer waggishly put it, "beautiful ladies…who seem to possess large fortunes and no inclination for any professional work."[99] Dewing's *Summer* (**fig. 76**) was painted as part of a triptych for a mansion in Detroit, the other two panels of which were produced by Dwight Tryon. Tryon grew up in Connecticut and was essentially self-taught as an artist, learning much of his early craft from books in the store where he worked as an assistant. No lesser a figure than the writer Samuel Clemens (better known as Mark Twain) advised him against giving up a good job in the hopes of becoming an artist, but in 1876 Tryon went to Paris where he eventually studied under the Barbizon painter Charles François Daubigny. After travel around Europe, Tryon returned to America in 1880 very much a French painter. He must have been aware of his famous compatriot Whistler while in Europe, but Tryon's work reflects little direct influence of the older American's work until after his return to his homeland. By 1893 Whistler's influence was paramount. Painted as foils to Dewing's *Summer*, no figures at all haunt Tryon's diaphanous landscapes *Spring* and *Autumn* (**figs. 75 and 77**), portraits of the seasons painted as if they were fading memories. The gold frames for the three paintings were designed by noted architect Stanford White, who frequently provided his artist friends with plans for original frames.[100]

John White Alexander, who had supported travel to Europe and study in Munich with the proceeds from a successful career as an illustrator in New York, was with Frank Duveneck in Venice when the latter met James Whistler. Exposure to Whistler's ideas, and ten years' residence in Paris, caused Alexander to abandon the dark palette of the Munich school in favor of lighter tones, more suitable for his "symbolist" paintings of the 1890s. *Panel for Music Room* (**fig. 78**), of 1894, depicts two women sprawled on a long bench, one playing a guitar, the other listening. The painting is a modern-dress equivalent of Millet's *Reading the Story of Oenone*, although the artist's interest lies not in narrative but in the shapes and lines caused by the voluminous skirts, sleeves, and collars, as if they somehow parallel the swelling and fading notes made by the guitar. Introspection and the communication between kindred souls is the underlying subject of the work.[101]

75
Dwight Tryon
Spring
1893
Oil on canvas
Bequest of Colonel Frank
J. Hecker
27.315

76
Thomas Wilmer Dewing
Summer
1893
Oil on canvas
Bequest of Colonel Frank
J. Hecker
27.316

77
Dwight Tryon
Autumn
1893
Oil on canvas
Bequest of Colonel Frank
J. Hecker
27.314

75

76

77

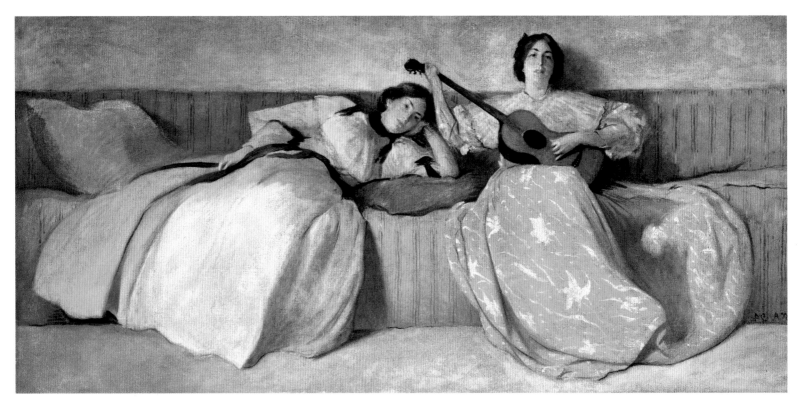

78

Interlude: Sculpture

78
John White Alexander
Panel for Music Room
1894
Oil on canvas
Founders Society
Purchase, Beatrice W.
Rogers Fund, Dexter M.
Ferry, Jr., Fund, Merrill
Fund, and Eleanor and
Edsel Ford Exhibition
and Acquisition Fund
82.26

79
Augustus Saint-Gaudens
Amor Caritas
1898
Bronze
Detroit Museum of Art
Purchase, Popular
Subscription Fund
15.9

By the end of the nineteenth century, sculpture too was being influenced by European artistic theories and tastes, while at the same time maintaining a strong link to the naturalism evident in earlier American works.

Augustus Saint-Gaudens was born in Dublin to a French shoemaker and his Irish wife who immigrated to the United States when their son was an infant. After work as a cameo cutter in New York, Saint-Gaudens studied at the National Academy of Design before going to Paris in 1867. He was admitted to the atelier of François Jouffroy, after a wait of a few months. Moving on to Rome in 1870, he came to the attention of wealthy American patrons, who were attracted by the vigorous naturalism of his works, and who paid for his return to America.

Saint-Gaudens's years of cameo cutting and his training in France developed his talent for working in relief, which he put to good use in the 1898 work *Amor Caritas* (**fig. 79**). A winged female figure, dressed in generalized classic garb that the artist referred to as "abstract," holds up a plaque bearing the words of the title, both of which mean love; one with pagan connotations, the other with Christian overtones. There is no story here, rather a generalized symbolism unusual in the work of a sculptor renowned for his portrayals of public figures. But, unlike the languorous classicizing females inhabiting the fin de siècle painted worlds of Frank Millet or Thomas Dewing, Saint-Gaudens's messenger is given energy through the agitated rendering of her garment and the upsweep of her wings.

Herbert Adams was in his late twenties by the time he went to Paris in 1885. He stayed there for five years, studying under Marius Mercié and establishing his own studio by 1887. In Paris he adopted the technique of tinting marble to produce lifelike effects, as is seen in his *Portrait of a Young Lady* (**fig. 80**). For a number of years there had been in Europe a lively debate about polychrome sculpture, following the realization that ancient Greek marbles had originally been painted. Artists in the Aesthetic, Symbolist, and Art Nouveau move-

80
Herbert Adams
Portrait of a Young Lady
1894
Polychromed marble
with bronze mounts
Founders Society
purchase,
Beatrice W. Rogers Fund
1987.77

81
Frederic Remington
The Mountaineer
1903
Bronze
Gift of George C. Booth
37.11

ments experimented with sculpture, combining various marble, polychrome, metal, and precious stones to create realistic and refined statues.

Adams brought his tinted marble technique back to America when he returned in 1890, and it quickly made him sought after. *Portrait of a Young Lady* is similar to other busts of young beauties that Adams executed in the mid-nineties and inscribed with such vaguely symbolic names as "Primavera" and "Marianna." The figure's hairstyle and the little that can be seen of her dress are reminiscent of medieval fashion, but, lacking any giveaway title, it is probably safe to assume that the young woman depicted here represents a portrait commission. Adams soon abandoned the tinting technique and adopted a bolder style, reflecting the naturalism of Augustus Saint-Gaudens. He never lacked for commissions and, although he ceased to be a force in American sculpture after the 1920s, he continued to produce portraits and idealized female figures well into his eighties.

Enrolled in Yale University's School of the Fine Arts, Frederic Remington set out for the American West when forced to leave school by the death of his father. He worked as a clerk in a general store and then as a cowboy, making sketches to pass the time. Returning to the East Coast, he studied art in New York for one year. For the rest of his life he worked for a variety of magazines, producing images of a Western way of life that he, unlike many of his readers, knew was on the verge of extinction. In 1893, the American historian Frederick Jackson Turner declared that the frontier was closed; Remington kept it open in the imagination.

By 1900, Remington was earning $25,000 as a retainer from one magazine alone, and his decision to work in sculpture was rewarded by immediate success: to meet public demand, more than two hundred versions of his first sculpture, *Bronco Buster*, were produced. But if the cowboys Remington depicted were a vanishing breed, the mountain men represented in his 1903 sculpture *The Mountaineer* (**fig. 81**) had already completely disappeared. The days of the fur trappers and guides

82

living in "Indian Territory" well beyond the frontier were over by 1850. In his sculpture, Remington captures the individualistic, independent spirit of the lone mountaineer, looking straight ahead at some imaginary horizon as his horse nervously picks its way down a steep, uneven incline.

While much of American sculpture of the nineteenth and early twentieth centuries was for public memorials and official portraits, Bessie Potter Vonnoh worked in an area far removed from the mainstream. Her work can best be described as a sculptural variation on the paintings of women and children made popular by Mary Cassatt, with a focus on the theme of mother and child or groups of children at play.

Born in St. Louis, she studied under Lorado Taft, subsequently becoming his assistant. It was in this capacity at the 1893 Columbian Exposition in Chicago that she encountered the work of Paul Troubetzkoy, whose relatively loose handling of surface and texture became a major influence on her own work. On the one hand, her 1921 *Allegresse* (**fig. 82**) looks back to the nineteenth-century language of the sylvan symbolism seen in the work of Julius Stewart; on the other it reflects the jaunty energy of such Art Deco modernizers as Paul Manship.

Mahonri Mackintosh Young grew up in the recently established settlement of Salt Lake City, Utah, the grandson of

82
Bessie Potter Vonnoh
Allegresse
1921
Bronze
City of Detroit Purchase
21.23

83
Mahonri Mackintosh
Young
The Rigger
1917
Bronze
Founders Society
Purchase, Elizabeth
Champe Fund
26.88

Brigham Young, the second leader of the Church of Latter Day Saints (Mormons). He studied for two years at the Art Students League in New York before going on to Paris, where he attended the Académies of Delécluse and Julian and studied painting and drawing. A visit to Italy, however, aroused his interest in sculpture, and he turned his attention in that direction, although he continued to paint. From the very beginning of his career he demonstrated a predilection for the theme of the "worker." In 1904, soon after his return from Europe, he won acclaim with his *Shoveler* and *Man Tired*. Loosely rendered and eschewing detail, his sculptural style can be described as a three-dimensional counterpart to the Ashcan's school of urban realism. *The Rigger* (**fig. 83**), a smaller version of a public commission, shows a tough-looking, broken-nosed worker hauling a hook onto an I-beam, which itself echoes the shape of a traditional plinth for sculpture. The pose of the worker, arm thrown back and leading shoulder down, recalls that of the *Discobolus* as Young compares the heroic effort of the modern day worker with the athletic, aristocratic discus thrower of ancient Greece.

83

The Eight

Whether painting New York or New England, the pioneer American Impressionists tended to edit out the more unpleasant facts of urban life, presenting what has been called a "euphemistic" view of their youthful society.[102] By the first years of the twentieth century, a number of artists had begun to turn away from the unruffled natural world of The Ten and look more closely at the real, and often unpalatable, truths of life as they existed for the majority of American city dwellers. Many of these artists had been trained in Impressionistic methods and they carried into their new realism a vigorous brushstroke that clearly derived from this experience. But their palette darkened and they favored strong contrasts; in place of the sweetness and light of the New England countryside, they preferred the dark and seedy streets and bars of New York's Lower East Side. These younger artists were led by Robert Henri, an avowed realist recently returned from Paris and earlier a pupil of Thomas Eakins. In 1908, following the rejection the year before by the National Academy of the work of George Luks, John Sloan, and William Glackens (all three of whom had been Henri's students in Philadelphia before his move to New York), Henri accepted the offer to exhibit with them in a show at a commercial gallery organized by another artist, Arthur B. Davies. The exhibiting artists, first called "Eight American Painters" but soon know simply as "The Eight," caused a furor, drawing abuse from many in the press who seemed to regard their realism as an attempt to besmirch the reputation of a great country. Despite the presence of several artists—Davies included—whose works were downright lyrical, the group exhibition was roundly attacked for its preference for realism. Ultimately, Henri, Luks, and Sloan, with the later addition of George Bellows, were to be known as The Ashcan School.

Henri stressed the urgency of the task at hand, rejecting hierarchy altogether in the creation of art: "It is the inventor in art who expresses the valuable idea," he wrote:

All colors are beautiful and all lines are beautiful and all forms are beautiful…when they are significant…if it does not express a thing that we greatly like, why then, it is not beautiful…Artists must feel within themselves the need of expressing the virile ideas of their country…and undoubtedly there is a great deal to be said in America that has never been said in any other land.[103]

The vigor of his prose is matched by the handling and composition of his 1907 painting *The Young Girl* (**fig. 84**). The model, posed nonchalantly against a substantial red form, is brightly lit and stares directly at the viewer. The startling red of her lips is complemented by the mauve shadow on her left cheek and the reddish brown of her hair. Henri is recorded as having said in his classes:

The nude is exquisite, the most beautiful thing in the world…a gleam of light plays all over the body of the model. The painting of the gleam depends more on change of color than of white…. Purple over there is more the *sensation* of purple than the color of purple. Don't think of them as paints, but get the quality of light.[104]

John Sloan met Henri, as well as George Luks and other future members of the Ashcan School, while studying at the Pennsylvania Academy of the Fine Arts and working as an illustrator for two Philadelphia newspapers. Sloan moved to New York in 1904, where he painted the working class going about their everyday lives. As an undogmatic Socialist, he depicted them with an affection that earned him the title of an American Hogarth. He was by no means immune from the miseries of urban life. His 1907 painting *Wake of the Ferry No. 1* (**fig. 85**), was inspired by the frequent departure of his alcoholic wife, Dolly, from Manhattan for her home in Philadelphia. The image of a lonely woman in the stern of the boat, watching its wake, is a poignant reflection on their fractured relationship and Detroit's painting itself was almost a casualty of one of their many rows. On a day after Sloan had been involved in a planning session for The Eight exhibition, he was angered when Dolly turned on him at a social gathering in his studio. A little the worse for a few drinks himself,

84
Robert Henri
The Young Girl
1907
Oil on canvas
City of Detroit Purchase
19.148

85
John Sloan
Wake of the Ferry, No. 1,
1907
Oil on canvas
Gift of Miss Amelia
Elizabeth White
61.165

85

86
John Sloan
McSorley's Bar
1912
Oil on canvas
Founders Society
Purchase, General
Membership Fund
24.2

Sloan picked up a chair and hurled it through a nearby can-vas: *The Wake of the Ferry*. He later repaired it, but not before he had painted a second version (now in the Phillips Collection, Washington, D.C.).

By the time Sloan painted *McSorley's Bar* (**fig. 86**) in 1912, the saloon was already an institution. Founded in 1854, its original owner had been dead for nearly twenty years. More than just bars, such places had served as social clubs for the working man. Sloan depicts this one in the dark tones of an Old Master painting, but picks out the many framed pictures on the establishment's walls. (Bars in New York had a history of informally exhibiting art in quiet imitation of more august places, such as the Century Association, founded by Asher B. Durand and other artists in 1847.) The barman and waiter are highlighted in their white shirts and apron, a customer taps his companion on the chest in a quiet gesture of emphasis. "Had all the saloons been conducted with the dignity and decorum of McSorley's," Sloan later reminisced, "prohibition would never have come about."[105]

The son of educated German immigrants, George Luks was a turbulent character given to brawling and acting on the amateur stage. After sporadic art training in Philadelphia and Düsseldorf as well as visits to galleries and museums in Paris and London, he returned to Philadelphia in 1894, took up painting seriously, and formed a close association with Henri. Following stints as an illustrator in Philadelphia and Havana, he moved to New York where he drew some of the now early classics of American comic strip art for the *New York World*: *The Yellow Kid*, *Hogan's Alley*, and *McFadden's Flats*. He painted the workers and urchins of New York's streets and the performers in the music halls with a broad brush, which echoed his artistic credo, itself a much simpli-fied version of Henri's emphasis on artistic character: "Technique do you say? My slats! Say, listen you—it's in you or it isn't. Who taught Shakespeare technique?...Guts! Guts! Life! Life! That's my technique."[106] Luks's reputation was built on his loosely brushed renderings of New York's under-

classes, notably the shop assistants, washerwomen, and street urchins of his paintings from the first decade of the century. *Three Top Sargents* (**fig. 87**), by contrast, it was entirely invented. It depicts a trio of musicians performing against a plain background, absorbed in their music making. The sit-ters were three illustrators for the *New Yorker* magazine: Walter Vanderburgh, Cy King, and Burley (first name unknown). They were "disabled veterans," but none of them top sergeants, who lived a few floors below Luks's studio. Dropping in on Luks at three in the morning, they were per-suaded by the artist's pleadings to stay and pose for him. "George Luks was paying the piper. Long layoffs, carousing, burning the candle at both ends was taking its toll. He needed a success, and a big one...He went to the maple highboy, procured a flute and guitar. Burley got the flute, Cy King the guitar. 'Now come on, group together, Burley, you in the middle...sing, God damn it, sing!' We opened with *Down by the Old Millstream*...George Luks was painting feverishly, desperately, as though the world was coming to an end."[107]

After the session the four all went out for breakfast, and when they returned to Luks's studio, his dealer, Frank Rehn, was there with another man, Clyde Burroughs, curator of the Detroit Institute of Arts. Burroughs "bought the painting, still wet, *The Three Top Sergeants*, started at three in the morning, finished at six, sold at ten thirty....*The Three Top Sergeants* was most important to George Luks. He had not had a smashing success for years." Knowing Luks propensity for returning to—and ruining—finished works, Rehn had the painting crated, still wet, and immediately shipped to Detroit. "It takes two to make a painting," Vanderburgh records Luks as saying, "the painter and a man in back of him with a ham-mer to hit him on the head when he's finished." Luks died from injuries sustained in a barroom brawl eight years later.

Although Ernest Lawson was included in The Eight exhibi-tion and often selected urban New York as his subject matter, his style and temperament were more allied with the older Impressionists. *Winter* (**fig. 88**), painted around 1919, demon-

87

strates a lingering affection for the tonalism of Whistler as well as the abiding influence of Monet. "Lawson…loves the seasons and their lights," said an early collector of his work, "for the sensations and emotions which they give," and the thick, encrusted and sparkling surfaces of his paintings were aptly likened by a contemporary critic to "crushed jewels."[108]

George Bellows was not included in The Eight exhibition but established his reputation as a painter of urban scenes—the building of Pennsylvania Central Station and prize-fights—redolent of energy and violence. Younger by a decade or more than Henri, Sloan, and Luks, the precocious Bellows was self-aware enough to realize that he benefited from the group's ground-breaking efforts and, following

exposure to contemporary European painting, modified his style and subject matter accordingly. He was particularly influenced by the theories Jay Hambridge laid out in his book *Dynamic Structure in Composition*, and the 1913 painting *A Day in June* (**fig. 89**) depicts a world far removed from construction sites or seedy bars. Here, elegant, white-clad figures populate a lush green park over which a celestial building sparkles in the distance. Such a scene has much in common with the Arcadian evocations of Matisse and Dufy and looks forward to the vibrant, fragile world of the 1920s as described in the novels of F. Scott Fitzgerald.

A similarly idyllic world is presented in the 1916 painting *In the Country* (**fig. 90**) by Leon Kroll. Kroll, too, had started

87
George Luks
Three Top Sargents
1925
Oil on canvas
City of Detroit Purchase
25.6

88
Ernest Lawson
Winter
Ca. 1919
Oil on canvas
Gift of Richard H. Webber
23.19

89

89
George Bellows
A Day in June
1913
Oil on canvas
Detroit Museum of Art
Purchase, Lizzie Merrill
Palmer Fund
17.17

90
Leon Kroll
In the Country
1916
Oil on canvas
Founders Society
Purchase, Special
Membership and
Donations Fund with a
contribution from
Mr. J. J. Crowley
19.35

91

91
Maurice Prendergast
Landscape with Figures
Ca. 1913–16
Oil on canvas
Gift of Dexter M. Ferry
24.30

out under the influence of the Ashcan School, but exposure in Europe to the art of Cézanne, Poussin, and Piero della Francesca led him to a more "timeless" approach. More radical was the work of Maurice Prendergast, a member of The Eight, who developed a distinctive style that owes much to Postimpressionist, Pointillist, and Fauve painting. He had studied abroad as early as 1886, where he encountered the work of Georges Seurat. For his subject matter, Prendergast favored people at leisure in parks or on boulevards, like Detroit's *Landscape with Figures* (**fig. 91**), which he rendered in mosaic-like patterns that give primacy to neither the figures, nor the landscape they inhabit.

With the work of these last few artists the long American search for realism, which had underpinned so much American art for so long—whether that of Copley or Church, of Homer or Henri—comes to an end. Although there was to be a continued commitment to the "American Scene," as represented in the paintings of the Regionalists (Thomas Hart Benton, John Stuart Curry) or the Precisionists (Charles Sheeler, Charles DeMuth) of the 1920s and '30s, the basic dialogue in art had changed. In 1913 an exhibition of recent art opened at New York's 69th Regiment Armory on Lexington Avenue. Among those who participated in its organization were Arthur B. Davies (organizer of The Eight), Bellows, and Prendergast. Designed to present to the American public new developments in art, it was a veritable *Who's Who* of Modernism. The Armory show presented not only the work of Monet, Sisley, and Renoir—artists generally familiar to the educated American public—but also introduced Cézanne, Matisse, Duchamp, and Brancusi as well as such younger, unknown Americans as Marsden Hartley and Alfred Maurer, who had been working in Europe. The result was a sensation, with the public and the general press predictably reviling much of the work (most famously, Duchamp's *Nude descending a Staircase* was likened to an explosion in a shingle factory). Artists, on the other hand, quickly understood the radically different options laid out for them. Ashcan painting

suddenly seemed academic, almost polite, by comparison with the colorful abstraction of Matisse or Delaunay. The expatriate Whistler's "art for art's sake" had returned in a new guise; Albert Pinkham Ryder was enshrined as an honorary Modernist. But while American artists' antecedents were asserted, few could escape the conclusion that the most recent homegrown American art was provincial and beside the point. Suddenly Paris mattered more than ever. It took less than four decades, however, for New York to supplant Paris as the center of the western art world, but when it did so, the work that gave it primacy would owe little or nothing to the earlier American search for beauty in the observed world.

Notes

1 Quoted in Jules David Prown, *American Painting: From Its Beginnings to the Armory* (Cleveland, 1970), 17.

2 The fact that the first native-born genius of colonial and revolutionary America was a loyalist is glossed over in most general texts on American art and still, apparently, has the ability to inflict pain. Reviewing a 1995 Copley retrospective, the American novelist John Updike, an ardent Yank, lamented "I winced to see so many bright redcoats and pompous lords rendered immortal by the Irish son of Boston's waterfront" and, while pointing out exceptions, goes on to characterize the "English" works as "faintly oppressive and slick…opaque and intimidating…in many ways disappointing." John Updike, "An Honest Eye," *New York Review of Books*, December 21, 1995, 61–62.

3 William Betham, *The Baronetage of England; or, the History of the English Baronets* (London, 1805), 540.

4 Ethan Allen, *A Narrative of Colonel Ethan Allen's Captivity. Written by Himself*, 3d ed. (Burlington, Vt., 1838), 44.

5 Samuel Isham, *The History of American Painting* (New York, 1905), 26.

6 Ann Uhry Abrams, "Politics, Prints and John Singleton Copley's *Watson and the Shark*," *Art Bulletin* 61 (June 1979): 265–76.

7 Quoted in Ellen G. Miles, *American Paintings of the Eighteenth Century* (Washington, D.C., 1995), 67.

8 *General Adviser and Morning Intelligencer*, April 27, 1778.

9 Quoted in Prown 1970 (note 1), 41.

10 William Carey, "Memoirs of Benjamin West, Esq., Late President of the Royal Academy of Painting, Sculpture and Architecture, in London," *New Monthly Magazine* 13 (1820).

11 Boyd Alexander, trans. and ed., *Life at Fonthill 1807–1822; with interludes in Paris and London: From the Correspondence of William Beckford* (London, 1957), 96.

12 William T. Whitley, *Gilbert Stuart* (Cambridge, Mass., 1932), 177.

13 Harold E. Dickson, ed., *Observations on American Art: Selections from the Writing of John Neal (1793–1876)*, Pennsylvania State College Studies, no. 12 (State College, Pa., 1943), 5.

14 Peale-Sellers Papers, American Philosophical Society, Philadelphia, Letterbook, vol. 17, August 2, 1822.

15 Ibid., December 7, 1822.

16 Rembrandt Peale, "Washington and His Portraits," 1857, Haverford College, Haverford, Pa.

17 Willian T. Odel in *American Paintings in the Detroit Institute of Arts,* vol. 1, *Works by Artists Born before 1816* (New York, 1991), 164.

18 "Autobiography of Charles Willson Peale," 1826–27, quoted in Brandon Brame Fortune, "A Delicate Balance: Raphaelle Peale's Still Life Painting and the Ideal of Temperance," in *The Peale Family: Creation of a Legacy, 1770–1870*, ed. Lillian B. Miller (New York, 1996), 138.

19 Paul D. Schweizer, "Fruits of Perseverance: The Art of Rubens Peale, 1855–1865," in Miller 1996 (note 18).

20 Gerald Carr in *American Paintings* 1991 (note 17), 170.

21 William H. Gertz, ibid., 100.

22 William T. Whitley, *Gilbert Stuart* (Cambridge, Mass., 1938), 89.

23 Frances Trollope, *Domestic Manners of the Americans,* ed. Donald Smalley (New York, 1949), 168.

24 New Haven *Leader*, 1893, cited in Berkeley, Calif., University Art Museum, *The Reality of Appearance*, exh. cat. by Alfred Frankenstein (New York, 1970), 112.

25 Alfred Frankenstein, *William Sidney Mount* (New York, 1975), 49.

26 Founded in 1838 as the Apollo Association, the Union used its membership dues to publish a newsletter, distribute engravings by contemporary artists to its members, and purchase a number of paintings to be distributed by lot at each annual meeting. Unfortunately, in one of those undiscriminating puritanical movements that periodically sweep across U.S. politics, the Union's lottery program fell victim to more broadly aimed anti-lottery legislation in 1852.

27 *Missouri Republican*, October 11, 1850, 2, cited in E. Maurice Bloch, *George Caleb Bingham: A Catalogue Raisonné* (Los Angeles, 1967), 76.

28 *New York Daily Tribune*, January 22, 1867, 2.

29 Washington, D.C., Corcoran Gallery of Art, *Richard Caton Woodville: An Early American Genre Painter*, exh. cat. by Francis S. Crubar (1976), n.p.

30 *Baltimore American and Commercial Daily Advertiser*, May 25, 1847, quoted by Gerald Carr, *American Paintings in the Detroit Institute of Arts*, vol. 2, *Works by Artists Born between 1816 and 1847* (New York, 1997), 254.

31 Carr (ibid.) reads the black man's expression as one of bemusement.

32 Eastman Johnson to Jervis McEntee, October 26, 1879, quoted by Patricia Hills in *American Paintings* 1997 (note 30), 152.

33 William Walton, "Eastman Johnson, Painter," *Scribner's Magazine* 40 (1906): 263–74.

34 Albert Boime, *The Academy and French Painting in the Nineteenth Century* (London, 1971), 28–29, quoted by Patricia Hills in *American Paintings* 1997 (note 30), 152.

35 Patricia Hills, ibid.

36 Helen M. Knowlton, *Art-Life of William Morris Hunt* (Boston, 1899), 84.

37 Ibid., 118–19.

38 *The Round Table*, 1866, quoted by Patricia Hills in *American Paintings* 1997 (note 30), 166.

39 B. A. Botkin, ed., *A Civil War Treasury of Tales, Legends, and Folklore* (New York, 1960), 384–85.

40 Quoted by Christopher Kent Wilson in "Marks of Honor and Death," in Fine Arts Museums of San Francisco, *Winslow Homer's Paintings from the Civil War*, exh. cat. (1988), 36.

41 Patricia Hills in *American Paintings* 1997 (note 30), 119.

42 Quoted by Nicolai Cikovsky Jr. in "Modern and National," in Washington, D.C., National Gallery of Art, *Winslow Homer*, exh. cat. (1995), 63.

43 Patricia Hills in *American Paintings* 1997 (note 30), 121.

44 "The Realm of Art. Gossip among the Brushes, Mahlsticks and Easels," *The New York Evening Telegram*, June 8, 1872.

45 Edgar P. Richardson, "'The Dinner Horn' by Winslow Homer," *Art Quarterly* 11 (Spring 1948): 153–57.

46 Quoted in Washington 1995 (note 42), 393.

47 Ibid., 179. Homer's works of his last two decades are almost exclusively powerful, loosely painted depictions of the sea and the people who live by and on it. The absence of one of these late works must be considered one of the few significant gaps in the Detroit Institute of Arts' collection of nineteenth-century American painting.

48 For a fuller account of the paradoxes confronting artists of the early Republic, see Neil Harris, *The Artist in American Society; the Formative Years 1790–1860* (New York, 1966), 28–53, 90–122.

49 Thomas S. Cummings, *Historic Annals of the National Academy of Design* (Philadelphia, 1865), 12.

50 Louis L. Noble, *The Course of Empire, Voyage of Life, and Other Pictures of Thomas Cole N.A.* (New York, 1853), 171.

51 John "Mad" Martin, a contemporary of Cole's, was a painter of spectacularly melodramatic scenes of catastrophe. Cole would have known of his work from engravings before he went to England, and American critics, disapprovingly, noted the influence.

52 *Broadway Journal*, January 4, 1845, 12–13.

53 Reported from a lecture at Astor House, New York City. *New York Evening Post*, March 13, 1849, 2.

54 Luman Reed, a self-made man who owned a great metropolitan grocery was, for a number of years, the most important single art patron in New York City. He encouraged Cole's ambitions toward epic landscapes, provided funds for Durand's European travels, and helped William Sydney Mount—who declined to travel—in other ways.

55 *The Knickerbocker* 16 (New York, July 1840): 81.

56 *The Crayon* 1 (New York, January 17, 1855): 34.

57 John Ruskin, *Modern Painters* (London, 1873), vol. I, pt. II, sec. I, chap. IX.

58 *The Crayon*, published from 1855 to 1861, was the preeminent art periodical of mid-nineteenth-century America.

59 Like so many terms used to describe art movements, "Hudson River School" was first used disparagingly, around 1879, by critics hostile to the work and who wished to support younger artists trained in French Barbizon methods. For a fuller account of the history of the term, see Kevin J. Avery, "A Historiography of the Hudson River School," in New York, Metropolitan Museum of Art, *American Paradise: The World of the Hudson River School,* exh. cat. (1987).

60 Respectively, the *New York Daily Tribune*, December 9, 1873, and *Appleton's Journal*, December 27, 1873.

61 Henry T. Tuckerman, *Book of the Artists: American Artist Life* (New York, 1867; reprint, 1967), 563.

62 See Avery 1987 (note 59), 7.

63 Jasper F. Cropsy, "Up among the Clouds," *The Crayon* 2 (August 8, 1885), quoted by Janice Simon in *American Paintings* 1997 (note 30), 59.

64 Gordon Hendricks, "The First Three Western Journeys of Albert Bierstadt," *Art Bulletin* 46 (September 1964): 337.

65 *New York Daily Tribune*, March 27, 1861.

66 Janice Simon in *American Paintings* 1997 (note 30), 101.

67 Heade, writing as Didymus, in *Forest and Stream* 53 (August 6, 1904): 111, and 37 (April 14, 1892): 348.

68 William T. Oedel in *American Paintings* 1997 (note 30), 137.

69 George Inness, Jr., *Life, Art, and Letters of George Inness* (New York, 1917; reprint, 1969), 175.

70 George Inness, "A Painter on Painting," *Harper's New Monthly Magazine* 56 (February 1878): 458–61.

71 Quoted in Richard McLanathan, *Art in America, A Brief History* (London, 1973), 155–56.

72 Both statements were by C. E. S. Wood, who owned the work. Wood described the long wait for the work and said that getting hold of it "would only be by tearing out his [Ryder's] heart, and on my later visits he would never even let me see it, telling me to wait until next time." See Lee Culver and Elizabeth Broun in *American Paintings* 1997 (note 30), 208.

73 Joshua C. Taylor, *William Page: The American Titian* (Chicago, 1957), 174.

74 William Page, *New Geometrical Method of Measuring the Human Figure, Verified by the Best Greek Art* (New York, 1860), 568.

75 William H. Bishop, "Elihu Vedder. First Article," *American Art Review* 1 (May 1880): 325.

76 Calder's long association with the mammoth City Hall project seems not to have been good for his reputation. He carried out a number of portrait commissions and, by the end of his life, saw his son Alexander Sterling Calder rise to prominence as a nationally recognized sculptor. The fame of both father and son has been eclipsed by a third-generation artist, Alexander Calder, inventor of the mobile.

77 *Illustrated Magazine of Art* 3 (1854): 263.

78 James Jackson Jarves, "Art Thoughts" (1869), in John W. McCoubrey, *American Art 1700–1960, Sources and Documents* (Englewood Cliffs, N.J., 1965), 299.

79 Jules-Antoine, *Salon of 1868*, quoted in Patricia Mainardi, *Art and Politics of the Second Empire: The Universal Expositions of 1855 and 1867* (New Haven, Conn., 1987), 187.

80 "National Academy of Design," *New York Times*, May 23, 1867, 5.

81 The art of Whistler, Mary Cassatt, and Julius Stewart was entirely shaped by their experience in Paris—as well as London in Whistler's case—and I am among those who feel that their art fits more comfortably into the history of English or French art. They are included here for three reasons: they exercised immediate and considerable influence on their compatriots back home; Whistler and Stewart especially placed great and repeated emphasis on their national origins; the works presented here were

acquired under the auspices of the Detroit Institute of Arts' Department of American Art and have consistently been shown in that context in our galleries.

82 William Rothenstein, *Men and Memories*, vol.1, 1872–1900 (London, 1931), 101.

83 John Ruskin, "Letter the Seventy-ninth," *Fors Clavigera* (July 1877): 181–213.

84 Linda Merrill, *A Pot of Paint: Aesthetics on Trial in Whistler v Ruskin* (Washington, D.C., 1992), 133–97.

85 For fuller treatment of the relationship between Cassatt's nationality and her preference for France, see "How Mary Cassatt Became an American Artist," in Art Institute of Chicago, *Mary Cassatt, Modern Woman*, exh. cat. (1998), 145–75.

86 Quoted by Judith A. Barter in "Introduction," ibid., 15.

87 Quoted by George T. M. Shackleford in "Pas de Deux: Mary Cassatt and Edgar Degas," ibid., 109.

88 Richard Ormond, "John Singer Sargent: A Biographical Sketch," in London, Tate Gallery, *John Singer Sargent*, exh. cat. (1998), 11.

89 See Ulrich W. Heisinger, *Jules LeBlanc Stewart, American Painter of the Belle Epoch* (New York, 1998), 37.

90 Quoted in ibid., 61.

91 Quoted by Ellen G. Miles in *American Paintings* 1997 (note 30), 80.

92 Dorothy Weir Young, *The Life and Letters of J. Alden Weir*, ed. Lawrence W. Chisolm (New Haven, Conn., 1960; reprint New York, 1971), 123.

93 M. de Varigny, "Revue des Deux Mondes," 187, quoted in Annie Cohen-Solal, *Painting American: The Rise of American Artists, Paris 1860–New York 1948* (New York, 2001), 111.

94 A. T. Rice, "Art[icle] VIII.—The Progress of Painting in America," *North American Review* 124 (May 1877): 164.

95 Lionello Venturi, *Archives de l'Impressionism*, vol. 2, *Memoires de Paul Durand-Ruel* (Paris, 1939), 315, quoted in Cohen-Solal 2001 (note 93), 73.

96 William M. Chase, "Painting," *American Magazine of Art* 8 (November 1916): 50.

97 A. E. Ives, "Talks with Artists: Mr. Childe Hassam on Painting Street Scenes," *Art Amateur* 27 (October 1892): 117.

98 Thomas W. Dewing in "John H. Twachtman: An Estimation," *North American Review* 176 (April 1903): 554.

99 Quoted in Lionel Lambourne, *The Aesthetic Movement* (London, 1996), 147.

100 For more on White's work, see Joyce K. Schiller, "Frame Designs by Stanford White," *Bulletin of the Detroit Institute of Arts* 64, 1 (1988): 20–31.

101 The two women are identical and the sitter appears to be Alexander's wife Elizabeth.

102 See New York, Metropolitan Museum of Art, *American Impressionism and Realism, The Painting of Modern Life*, exh. cat. (1994), 3–13.

103 Robert Henri, "Progress in Our National Art…A Suggestion for a New Art School," *The Craftsman* 25, 4 (January, 1909): 388, 394–99.

104 Robert Henri, *The Art Spirit, Notes, Articles, Fragments of Letters and Talks to Students….Compiled by Margery Ryerson* (New York, 1923; reprint, 1983), 263.

105 Quoted in Andover, Mass., Addison Gallery of American Art, Phillips Academy, *John Sloan Retrospective Exhibition* exh. cat.(1938), 62.

106 Quoted in Edward Lucie-Smith, *American Realism* (London, 1994), 67.

107 The quotes relating to the creation of *Three Top Sergeants* are taken from a manuscript, "The Three Top Sergeants," written by Walter H. Vanderburg, circa 1960, in the files of the Detroit Institute of Arts.

108 Duncan Phillips, "Ernest Lawson," *American Magazine of Art* (May 1917): 260–61, and E. Newlin Price, "Lawson of the Crushed Jewels," *International Studio* 78 (February 1924): 367.

Further Reading

Craven, Wayne. *American Art: History and Culture.* New York, 1994.

Detroit Institute of Arts. *American Paintings in the Detroit Institute of Arts,* vol. 1, *Works by Artists Born before 1816.* New York, 1991.

Detroit Institute of Arts. *American Paintings in the Detroit Institute of Arts,* vol. 2, *Works by Artists Born between 1816 and 1847.* New York, 1997.

Driscoll, John. *All That Is Glorious around Us: Paintings from the Hudson River School.* Ithaca, N.Y., 1997.

Lucie-Smith, Edward. *American Realism.* London, 1994.

Miles, Ellen. *American Paintings of the Eighteenth Century.* Washington, D.C., 1995.

Weinberg, Barbara H., Doreen Bolger, and David Park Curry. *American Impressionism and Realism: The Painting of Modern Life, 1885–1915.* New York, 1994.

Zurier, Rebecca, Robert W. Snyder, and Virginia M. Mecklenburg. *Metropolitan Lives: The Ashcan Artists and Their New York.* Washington, D.C., 1995.

Index of Artists

Adams, Herbert 108
Alexander, John White 102, 106
Allston, Washington 15, 16
Badger, Joseph 8
Bellows, George 112, 120
Benson, Frank Weston 100
Bierstadt, Albert 61
Bingham, George Caleb 35, 36
Blakelock, Ralph 68
Brown, Henry Kirke 76
Calder, Alexander Milne 77
Cassatt, Mary 82
Chase, William Merritt 95
Church, Frederic Edwin 46, 52–3, 54–5
Cole, Thomas 48
Copley, John Singleton 6, 8, 9, 10, 12, 13
Cropsey, Jasper 58
Dewing, Thomas Wilmer 105
Doughty, Thomas 49
Durand, Asher B. 51
Duveneck, Frank 94
Eakins, Thomas 91
Francis, John F. 27
Goodhue, Harriet 75
Haberle, John 31
Harnett, William Michael 28
Hassam, Childe 98
Heade, Martin Johnson 62, 63, 64
Henri, Robert 114
Homer, Winslow 42, 45
Hunt, William Morris 40
Inness, George 68
Johnson, Eastman 38
Kroll, Leon 121
Lambdin, George Cochran 32, 41

Lawson, Ernest 119
Luks, George 118
Mackintosh, Mahonri 111
Melchers, Gari 88
Metcalf, Willard Leroy 97
Mignot, Louis-Rémy 56
Millet, Francis Davis 86
Mount, William Sidney 34
Page, William 70, 71
Paxton, William 101
Peale, Charles Willson 20
Peale, Raphaelle 24, 26
Peale, Rembrandt 21, 22
Peale, Rubens 26
Peto, John Frederick 29
Powers, Hiram 74
Prendergast, Maurice 122
Remington, Frederic 109
Rimmer, William 42
Robinson, Theodore 92, 96
Ryder, Albert Pinkham 66, 69
Saint-Gaudens, Augustus 107
Sargent, John Singer 83, 84, 85
Sloan, John 115, 116
Stewart, Julius 87
Stuart, Gilbert 18
Sully, Thomas 19
Tryon, Dwight 104, 105
Twachtman, John 99
Vedder, Elihu 73
Vonnoh, Bessie Potter 110
Ward, John Quincy Adams 77
West, Benjamin 14
Whistler, James McNeill 78, 80
Whittredge, Worthington 57
Woodville, Richard Caton 37